Minstrels of Soul

Intermodal Expressive Therapy

Paolo Knill

Helen Nienhaus Barba

Margo N. Fuchs

E·G·S
PRESS

Minstrels of Soul
Intermodal Expressive Therapy

ISBN 0-9685330-3-5

Cover Image: Daisies — Joachim Knill, © 2003

E·G·S
PRESS

283 Danforth Avenue, #118
Toronto, Ontario M4K 1N2 Canada
tel 416 829-8014
www.egspress.com
info@egspress.com

OTHER TITLES AVAILABLE FROM EGS PRESS:

Tending the Fire: Studies in Art, Therapy and Creativity
(Ellen Levine)

Crossing Boundaries: Explorations in Therapy and the Arts—
A Festschrift for Paolo Knill
(Stephen K. Levine, Editor)

POIESIS: A Journal of the Arts & Communication
Published annually

Printed in Canada

CONTENTS

Minstrels of Soul

Intermodal Expressive Therapy

FOREWORD to the Second Edition

Introduction

Eight years have passed since *Minstrels of Soul* set forth the state of the art of Intermodal Expressive Arts Therapy. Much has happened since then in the application of "Intermodal Expressive Arts" (EXA), as we call the field today. In the foreground, we find a diversification toward supervision, consulting and coaching, which has prompted specialized training programs in both Switzerland and Germany. Research and development in connection with the increased demand for a larger application of EXA has also became relevant for the field of therapy. A detailed account of the philosophical, theoretical and practical consequences will be published in the forthcoming books, *Principles and Practices of Expressive Arts Therapy: Towards a Therapeutic Aesthetics* (Jessica Kingsley Publishers, London) in English and *Das Werk als Lösung* ("The Work as Solution" – working title) in German. The restricted format of a Foreword will allow us to introduce here only one of the major methodological achievements that have been developed since the first edition of *Minstrels of Soul*: **Intermodal Decentering.** Herbert Eberhart, Paolo Knill and the staff of the training institutes in the **Foundation EGIS** and the **European Graduate School**, both in Switzerland, developed this method during the nineties.

At a time when the practice of change agents is under so much pressure by restrictions of social services on the one hand and an opening in the private sector that demands innovation and effectivity on the other hand, it is essential to look for a stable foundation that could be shared by all the practices of change agents. In an attempt to go back to the basics, we have studied therapeutic actions, interventions or settings that are consistently present in all methods and that seem to be essential to the characteristic features of interventions directed toward change.

In Part I of the first edition of this book, we made reference to the continuity principle. We noted that even though there are great differences in the methods applied and their underlying beliefs or meta-theories, there is a commonality to be found in the conditions that lead to the process of change. We will share here two of the major concepts that seem pertinent to the activity of change agents. One we call, "decentering into an alternative experience of worlding," and the other, "increasing the range of play" [Spielraum].

All "rites of restoration" (as we call the professional practice of change agents in general) have a spatial and temporal frame that distinguishes them from everyday reality. We have considered, in these containers of change, the role of the "professional" change agent, who is ordained or specifically trained for this role. When we looked for more common characteristics, however, we realized we needed also to examine the separation of realities that occur in the performance of these rites of restoration.

Personal inability and situational restrictions experienced in everyday reality could be said to be part of the habitual experience of worlding[1] of the suffering or troubled human being.

The one asking for help has reached the "limits" or is on the "edge" of dis-ease. When problems are closing in so much so that no solutions can be in sight anymore, one speaks of being "stuck," being "against a wall," being "cornered," having reached a "dead-end" or treading on the "same spot." These images suggest limits and boundaries that restrict the possibility of finding ease. It seems there is not enough room to get around the impossible; and the one who asks for help has either the sense of lacking the skill to get around it, lacking the resources to make more room, or both. In addition, the person who is unable often painfully experiences himself as being worthless; and the lack of resources are felt with the bitterness that comes with blame or self-blame. We call this the "dire straits situation."

It should be noted that the two characteristics of the phenomenon, situational restrictions and personal inability, are interdependent. The predicament also may have the characteristics of literal reality (e.g., unemployment) or fantasy (e.g., paranoid thoughts). The experience of "worlding," as we call it, of a person seeking help seems to be a closed one, having no exit and lacking an adequate "range of play."

Even when the rites of restoration have a clear spatial and temporal separation from everyday reality, there will always be sequences where that reality is concretely addressed in interactional practices connected to the habitual experience of worlding (e.g., conversational language and nonverbal cues). This is evident, for instance, in the opening and closing of a session, the "filling in" phase, that the change agent uses to get familiar with an issue, problem or conflict, and in the "harvesting" or reflective phases that serve clarification or interpretation.

Of great interest, however, is that most rites of restoration initiate a phase or phases where an *alternative experience of worlding* is introduced, through practices that engage imagination. Examples are:

- Focusing on dreams, visions, etc.
- Daydreaming, free association or guided imagery.
- Wish-oriented discourses, such as "what would happen if ..."
- Body language and its imaginary potential ("What is your shoulder saying?", or "What does that pose express?").
- Making art (drama, painting, masks, ritual dance or performance, etc.) or other methods of creative work.
- Using works of art (music, texts, photos, paintings, movies, etc.).
- Using cognitive imaginal methods such as "change of perspective."
- Desensitizing with pictures.
- Brainstorming.
- Using metaphors.

In such a phase, the person seeking help is not in the habitual experience of worlding as in everyday life. Usually with the help of the change agent and the use of imagination, without necessarily going into a trance state, being in this world is not experienced as habitual. The things emerging in this imaginary space are sur-

prising or unexpected; it is truly an "other" or "alternative" experience of worlding. It is important that the events or things emerging from the imaginary space be unpredictable. In the dream this phenomenon is fully experienced as not being in one's control. There is a similar sense of having little control in free association or guided imagery methods, while some control is exerted in the practice of artistic disciplines. However only in the arts is there a "thingly" presence of the image, which all those present can simultaneously witness.

The alternative experience of worlding and the logic of imagination.

In the imaginary space that is emerging, things in their surprising unpredictable unexpectedness are still logical and describable. These things however happen differently than in everyday life and its narratives. This difference expands the "range of play" in the restrictions in everyday life which are reflected in the story of the distress. Therefore change agents apply methods of bridging the two experiences, in order to find inroads for a change, clarification or understanding that eases the distress. In psychotherapy, for instance, this bridging is usually called "interpretation."

To guide the client from an alternative experience of worlding in the *step back into everyday life* is part of the rites of restoration. Most change agents believe that it is possible to have a different relationship to everyday life, if the logic of imagination, in its symbolism, has been understood and has found meaning for that daily reality. The different schools of psychotherapy are distinguishable by their theories of interpretation (hermeneutics) for this process. It is essential here to understand that any guided step back is an interpretational act. Differences in theory exist in the epistemological assumptions about "who" (client and/or change agent) and "what" (meta-theory) is guiding us on that step. Even the so-called "phenomenological" approach, which is guided by the emerging "thing," is an interpretation, a kind of a response or answer.

The alternative experience of worlding has two sources that may be anchored in everyday life. In addition to the symbolic content of imagination, there is also an affective sensory experience that is addressed especially in body-oriented practices and also to an extent in all other psychotherapies, from art-oriented, "focusing" and counseling to many psycho-dynamic and humanistic schools.

Both resources of the alternative experience of worlding are usually used in the process of interpretation. As a consequence, the phases of the alternative experience of worlding are framed by an entrance and an exit. In the entrance, the client leaves the troubled logic of daily life and enters the logic of imagination. At the exit, we are challenged with the difference as a confrontation. This "in and out" may be repeated several times or may be connected to a long phase in the center of a session. Characteristic of all the "ins and outs" of the alternative experience are aspects of "decentering" and "expanding the range of play."

- By "decentering," we name the move away from the problem-bound narrow logic of thinking and acting that marks the helplessness around the "dead end" situation in question. We move into the opening of the surprising unpredictable unexpectedness which is part of the logic of imagination. Finally, the change agent closes the decentering by a centering phase, relating the two in an effort to find ease.

- Providing a "range of play" contrasts with the situational restrictions experienced by the seeker of help.

Decentering, an Indispensable Condition for Alternative Experiences of Worlding.

The positive effect produced by the decentering that we observe is manifested in many theories. Watzlawik, for example, demonstrates that centering on the problematic matter has a tendency to produce more of the same and therefore tends to worsen the situation. A decentering attitude, such as we can induce by brainstorming, for instance, opens doors to unexpected solutions.

Theories of imagination explain that imagination is not totally controllable; it is predictable only in its unpredictability. We can distinguish three realms of imagination. The dream space is the least controllable; the daydream and trance space allow some guidance; and artistic activity has characteristics of both dream and daydream. However only the phenomenon of imagination is embodied in an art-work that can be seen, heard or touched simultaneously by both "artist" and witness. The importance of all these

realms of imagination is recognized by psychoanalysis in its elaboration on the symbolism of the unconscious, by the humanistic schools in the validation of inner resources as a human potential; and, in the phenomenological schools in the view of artistic imagination as the existential that shapes meaning. C.G. Jung declared early on in his writings that the artistic act is of special value because it is a thingly dream that can be witnessed. His understanding was that rather than painting a dream, in the act of painting, the dream continues on the canvas (Chodorow, 1997).

The words we use in the context of decentering activities that open the door to the unexpected surprises are often "*spontaneity*" or "*intuition.*" Although coming from another theoretical background than ours, these words nevertheless point in the direction of an alternative experience of worlding through distancing.

The exit out of the narrow situational and personal restrictions of the help-seeker, through entering a space of imagination, allows in its decentering also a distancing from one's personal fate. This distancing happens in Jungian analysis within the container of archetypal mythology, in drama therapy through relating roles or stories of the world of theater, and in postmodern psychology through a distancing within the historic multiplicity of narratives.

Intermodal Decentering:
"Exercising" the Arts in Decentering

Even though all the methods of decentering that engage imagination in one or another way offer the aforementioned opportunities of an alternative experience of worlding, the artistic process in this context, however, offers options that are unique to an intermodal decentering.

Direct witnessing of the artistic work as a materialization of imagination: The presence of a thingly act or object, e.g., a painting, a sculpture, a poem, a scene, a music improvisation, a dance or a work of performance art, is there to be witnessed directly, both by the client and by the professional change agent. In such an instance, we do not depend solely on the interpretation of clients, as is the case when they talk about dreams, visions or daydreams. The story about a dream does not reveal the original image that the client saw but rather my image of that story, which itself is my client's account of the original imagery. Interpretations within the

artistic mode of imagination, though, happen in the presence of a "third" thing, the emerged thingly work in process. This allows a confrontational field of acts and discourses, on the basis of an embodied emergence. As Bodenheimer (1997) states, this confrontational field, handled more or less playfully and in an exploratory manner, can lead to either "explanatory interpretations" (e.g. depth psychological, bioenergetic and spiritual schools) or "answering interpretations" (e.g. existential, humanistic and solution-focused schools).

Intervention within the thingly process of shaping: The complexity of an imaginary reality on the basis of the literal shaping of material permits interventions that are concrete and deliberately placed "on the surface." These interventions can serve in the purpose of grounding and testing reality. We may probe, for example, in a painting session, by suggesting a bigger paper, adding more water to the color or closing one's eyes for a while. Similarly we may suggest to a "dancer" to use more space or to a "musician" to add the voice to the instrument.

Interventions with the "work of art" (oeuvre): The "in and out," to and from the alternative experience of worlding and its reality, is discernible through the here and now of the artistic work, its initiation, process of becoming and completion as a "thing." In its graspable presence, the work offers many options in helping to distinguish between the different realities. The distinction of stage, canvas, studio space, audience space and the habitual experience of worlding is concrete and sensorimotorically explicit. In theater, for instance, it can be shown that an act of killing does not call for a literal ambulance or police officer; but perhaps another actress can provide these roles. Similarly, a painting of a fire will not literally raise the temperature in the room; however it may evoke a fear of burning or the joy of a bonfire. In this way, fiction becomes a reality to explore certain images with the full power of experience in perception or in the making, without, however, literal consequences within the "scene."

A personal enabling and a situational coping with the achievement of the artistic work: As we pointed out in the beginning of this Foreword, an experience of distress or dis-ease is marked by a situational restriction and/or individual inability. In the art-oriented

work, within the rites of restoration, there is, however, the affective experience (literal, not symbolic) of enabling and achievement within a frame of limited resources. It belongs to the basic methodological skills of any art-oriented therapist to enable people who are not artists and usually have a sense of "not being talented" to engage in art disciplines of some sort and to find satisfaction. Furthermore, these professional change agents are trained to understand one of the essential phenomena of the arts: the role of limiting resources within a restricting frame in order to reach beauty. Consequently the experience of an art-oriented decentering is literally a coping experience in a situation of restriction in which one discovers resources. The help-seeker might have expressed an inability to paint; and, in addition, there might have been a resistance to paint in black and white only. However, at the end, we may be in front of a painting that makes sense.

Diet and Medicine: The concept of "diet and medicine" reaches far beyond the physical metabolism of the body. The word, "diet," (in Greek, *diaita*) means originally a manner of living. Later it was used for a regulated manner of living to maintain health; and finally it made exclusive reference to eating habits. Within a psycho-somatic understanding, we could extend it to the regulated nourishment of psyche or soul. In terms of such a concept, the word "diet" would also concern a corrective regulation of psychic nourishment and metabolism. In this sense, art-making could be viewed as an essential part of a healthy diet.

We can apply a similar reasoning to the concept of medicine. A substance must have two characteristics in order to qualify for a medicine. First, it must be composed so it can be metabolized by the system; second, it must interact in a constructive way with the self-regulating forces in the system. The work of art, as a phenomenon of the inter-structural relationship between everyday and imaginal realities, is a remarkable entity within rituals of restoration. It is particularly suitable for a metabolism in the psychic system in question. In fact, one could see the art work as that which arrived exclusively for that very system, even though it should not be confused, from a phenomenological perspective, with a mirror image or an appearance of the system's identity (Knill, in Levine and Levine, 1999).There are many traditional ways of relating to the art work that also satisfy the criterion of the second quality of a med-

icine. The transpersonal theory of Intermodal Expressive Art Therapy gives clues as to how pictures that are mounted may have the characteristics of a totem or an altar, how poems that are performed out loud may have effects like prayers or mantras, how a song or music may console and how a mask may help to allay fear when played. The exercise of the arts, in the decentering phase, provides the possibility of giving "prescriptions" that may have an effect beyond the session time, as the following examples demonstrate (Knill 1999):

• Paint daily! Go to your easel instead of to the TV monitor ("Diet").

• Read the poem that helped you in the session today every time your thoughts get stuck on that theme ("Medicine").

• Make a visible place for this sculpture and look at it each time you get lost in these doubts again ("Medicine").

**Providing a "Range of Play" [Spielraum] –
An Indispensable Condition for Alternative World
Experience**

The "doing as if" or the "we could now be..." in a play space will always have temporal, spatial or situational aspects. These "spells" allow a distinction from the literal everyday space, time and situation and open up to an alternative world experience that offers unforeseeable and unpredictable options.

The idea of widening the range of play by engaging imagination is a common concept in the practices of *Conflict Resolution*. Conflicts are seen in these practices as situations that lack choices and give participants a sense of being locked into the matter of conflict (neurosis can also be understood as a narrowness of that kind). Decentering, therefore, gives an opportunity to leave the zone of conflict with an opening to options for new actions and thoughts.

Therapeutic methods based on *Systems Theory* are based on the assumption that a simultaneous intervention through perturba-

tion and a widening of the range of play may be effective for a surprising auto-poetic process of improvement. The impetus for discovery and fear are in balance in such a type of play. Art disciplines can be seen as disciplines of play in which the probing of the artist is a kind of perturbation and in which self-organization happens within the range of play defined by the frame's and the discipline's restrictions (material, space, time, and means). The therapist is a player in the system who does not play the habitual game of the family, a popular saying about family therapy which is true also for many performance art-oriented therapies. Many music therapists as well play together with an individual client using this option.

We distinguish between "play," "game" and the "play disciplines of the arts" (one still says, "play music," "go to a play" and "play a role"). It is interesting that only the play therapists were able to join in one association uniting all schools of psychotherapy. My assumption is that the strong belief in the method of non-directive play shared by all play therapists, regardless of the school they come from, makes this unity possible. If we extend this argument further, it should also be possible that all change agents who practice the disciplined play of the arts or the play of ritual could find a common denominator and join together. Perhaps the difficulty lies in the answer to the questions: Why is it that non-directive play therapy with children is so successful and is used by many expressive arts therapists when they work with children, and what makes these therapists stick to the arts or ritual play when they work with adults?

In order to answer this question we need to look at the difference between the characteristics of the child's and the adult's play. Children, in contrast to adults, still have access to incantation and magic; they can cast a spell into a scene or role with one sentence, often without a stage and almost no props. "You be Dad now;" "I'll be drunk," etc. Adults have lost such naiveté and innocence. It does not astonish us, therefore, that play needs to become ritualized for adults to engage in it. In essence, we can make the following distinctions for providing a range of play with children and with adults:

- Providing a range of play through non-directive play with individual children is well-established in expressive arts play therapy. Themes like sexuality, alcoholism and death may come up, posing no more difficulty than other

issues like anger, rage, sadness or extreme regression. A reason for this is the child's naiveté and innocence and his/her ability to move in and out of imagination with "incantation and magic." (The play therapist is also aware of the precautions necessary when working with abused children.).

• The experience and the potential in the adult's reality that therapists know and hold in these difficult realms, however, require a disciplined form of play, a frame that facilitates the distinctions of realities. It is conducive, then, to use the expressive arts in providing a "range of play." The expressive arts offer:

The stage, the canvas, the dance studio, the art atelier, the distancing into fiction. Ritual containers give permission to approach these themes playfully, because the frames make clear distinctions between the realities. The ancient "Death Dance" or "World Play" (still performed by the village community in Einsiedeln, Switzerland, in front of the cloister) allow members of the community to play out all these roles and scenes, both dark and light, that belong to humanity without suffering sanctions in everyday life. This is an example of what we might call, "archaic ritual play."

How does Intermodal Decentering provide a disciplined "Range of Play"?

The practice of the arts in rites of restoration – a kind of play therapy for adults: Freedom and restriction, which provide the frame for any play within the arts, allow the distinction of realities through generally understood art traditions. With the exception of an acute clinical situation, we usually find a tacit knowledge and a fairly good understanding among clients about the "imaginary reality" in theater and movie plays or musicals, even though the fantasy identification can sometimes become very intense. Also, the popular stage (*Volksbühne* in Germany) is still a frame for playful explorations of different realities. The well-guided structures of any art discipline allow one to shape difficult themes that would be

hard to express or explore otherwise and can build on much tacit knowledge about such frames, if explained carefully, taking into account the condition of the client in question. The discipline of the arts is an anchor of hope, so to speak, which helps to distance oneself from the narrow ties of a single narrative about one's self-concept or destiny.

Arts disciplines allow clear interventions: The limits and boundaries that define the frame of an art discipline with respect to space, time, material and method of shaping belong to the tradition of art-making. Therefore *interventions* with respect to limits and frame are easily accepted and understood. These interventions and those during the process of the play may possibly restrict the range of play, but usually they do not restrict the act of playing and its content; on the contrary, they make the playing less threatening. Furthermore, the interventions help to distinguish between the different realities. Examples of such interventions might be:

"Stay with your marimbaphone now. If you want to change to the drum later, take one that is available for the next improvisation; the drum of Tom is already being used in this current one!" (in the event of an intrusion on somebody's drum)

"This character is alive onstage only; offstage you are Mary the actress right now; and we want to discuss the next act for the moment. We will go on in a minute!" (in a situation of role confusion)

The advantage of these interventions is that they are grounded in the tacit knowledge of the arts studio practice and not bound to moralistic disciplinary actions.

Play within the arts as a kind of focusing: Trance-like presence during the disciplined play in the arts is focused on the "surface" and manifests itself in material, structure and form in the act of shaping. The challenges inherent in the process of this shaping are in an existential relationship with the habitual world experience in everyday reality and therefore can be symbolically and experientially meaningful. There is a meaning found in the analogous character of the challenge posed by the artistic shaping with the challenge posed in the habitual world experience of the client; through shaping the work, the client has an experience of capabil-

ity which he or she can "transfer" to the restricted situation of their
everyday reality.

Play as experiential learning: The accomplishment in art-
making is a literal enabling which has the merit of beauty that can
evoke responses that "move" or "touch" us. In consequence this
distinct response of "completion" in the disciplined play within the
arts is therefore also a learning experience that provides an indi-
vidual enabling and a situational coping. The effect of this experi-
ence is both cognitive and physical. We can observe it in the
change of emotion, mood and tone of the participant. This coping
process can also be seen as a training or "exercise" to cope with
the situational restrictions and individual inability in the help-seek-
er's life. From a cognitive frame of reference, the coping experience
in the artistic process confronts beliefs within the scope of, "I am
not able to accomplish anything," "I am not talented, I have too few
resources," etc. Art-oriented therapy, however, includes more
levels than only the level of cognitive argumentation:
 • Such a form of therapy is also a rich exercise with
 repetitive experiences of accomplishment.
 • It is a psychophysical concrete experience that allows
 emotional as well as cognitive reasoning.
 • It is a sensory aesthetic experience that *touches*, that is
 a "nourishment of soul." All the senses are engaged; and
 in its beauty, it *makes sense*.
 • Beauty, as something that touches, can be motivating
 and convincing, bypassing the barriers built by cognitive
 reasoning and the logic of resistance and fear.
 • With the repetitive experience of coping, beliefs in one's
 lack of competence and ability are challenged. Moreover,
 the act of having created a work that gives satisfaction and
 pleasure to the eye of the beholder is quite a confronta-
 tion to those convictions. There is a kind of contribu
 tion that adds beauty to the community that is rewarding
 to the maker and the audience. From the perspective of
 learning theory, one could see this experience as an
 aesthetic reward or a rewarding "soul food."
 • Art-oriented therapy is also an experiential field of dis-
 covery that motivates curiosity. Discovery of this kind is
 one of the fundamental sensorimotor and cognitive learn-
 ing experiences. The challenge, then, will be to bridge the

discoveries of experience in this field of play with the issues of the clients in their everyday reality.

In the traditional understanding of coping, a structured practice is fundamental. In intermodal decentering, however, the process is guided with an attentive supportive attitude that is open; and the dialogue is lead with open questions. Openness in practicing the arts is a necessary condition in gaining access to the material and the symbolism emerging through the art-work and/or play. This dimension in the practice of the arts is not restricted by the logic of the habitual world experience and is not necessarily available by means of the usual coping methods. The openness gives what is hidden a chance to be met and to be utilized as a resource. With this result, options arise – new perspectives, fantasies, ideas, and images of alternative ways to act or respond to the restrictions of everyday life.

Footnote

1. We use the term "reality" as synonymous with "world." All experiences are within world. We use the word "world" here without a definite article ["the"] to make evident that world is not a thing or object. We are so to speak "within it "or "part of world." World is therefore in a way also within our thinking and action. For these reasons, I have used the term "worlding" in the text. (Cf. Fink, 1960).

References

Chodorow, J. *Jung on Active Imagination*, Princeton University Press, 1997

Bodenheimer, A,R. *Verstehen heisst Antworten*, Reclam UB 8777 Stuttgart 1997

Fink, E. *Spiel als Weltsymbol.* Stuttgart: Kohlhammer, 1960

Knill, P. "Soul nourishment, or the intermodal language of imagination," in *Foundations of Expressive Arts Therapy: Theoretical and Clinical Perspectives*, Levine, S.K. and Levine, E. eds., Jessica Kingsley Publishers, London 1999

Levine, S.K. and Levine, E. eds. *Foundations of Expressive Arts Therapy: Theoretical and Clinical Perspectives*, Jessica Kingsley Publishers, London 1999

Levine, S.K. *Poiesis: The Language of Psychology and the Speech of the Soul*, Jessica Kingsley Publishers, London 1997

ACKNOWLEDGEMENTS

It is with great respect and humility that we take this opportunity to acknowledge the many people who have contributed to the development of intermodal expressive therapy. First and foremost, we pay tribute to the masters and doctoral students at Lesley College Graduate School (now Lesley University), the trainees at the affiliated International Institutes, and our peer facutly members, who have taught and inspired these students of intermodal expressive therapy under the auspices of the former Institute for the Arts and Human Development. We have ourselves been repeatedly inspired by students' questions and learned from their investigations, inquiries and thesis research. This work, which stems from a deep faith and an abiding love for the arts, would not have been possible without the lasting commitment and inspirational challenge we all received from the founder of the Arts Institute and our mentor, Shaun McNiff.

We express further appreciation to Stephen K. Levine, for his philosophical guidance; to all our colleagues in the International Network of Creative Arts Therapy Training Centres, for their steadfast support; to the pioneers of this

network in Europe: Hans Helmut Decker-Voigt in Germany, Annette Brederode in Holland, Gunda Gränicher in Switzerland, Philip Speiser in Norway and Sweden, Yaacov Naor in Israel; and to those who inspired this network in Canada and the United States: Jack Weller, Natalie Rogers and Ellen Levine.

Should the history of expressive therapy one day be written, an additional tribute is owed to Steve Ross, who dared to found the first association of expressive therapists, and also to Dick Wylie, former president of Lesley College Graduate School, who guaranteed the freedom necessary to develop the field academically, and to the founders of the new International Expressive Arts Therapy Association (IEATA), who are carrying the spirit of this work into the world arena.

Our thanks also to the following journals: *The Arts in Psychotherapy* and *C.R.E.A.T.E.* (Journal of the Creative and Expressive Arts Therapies Exchange), in which some of the material in this volume has appeared in slightly different form.

The text which follows emerged as a direct extension of Paolo Knill's research and practice as first articulated in his text, *Intermodal Learning in Eduation and Therapy* (published by the author in 1978 in Cambridge, Massachusetts and later translated into the book *Ausdruckstherapie*, 1979). This updated version of the book – with several new sections on realities, beauty, research, the therapeutic relationship, and an expanded look at practical considerations – represents a truly collaborative effort in that we all participated in the process theoretically, artistically and philosophically. Therefore, we wish finally to acknowledge each other: Paolo, for his original theories and continually evolving ideas and inspirations; Margo, with her contributions of poetic texts and mindfulness to philosophical questions; Helen,

who assumed responsibility for the formulation and editing of the book, while also promoting an ongoing dialogue between the three of us, forcing us to clarify our thoughts and ideas.

PREFACE

My favorite mode is whatever helps me move from one insight, mood or state into another—and to pull meaning and momentum from the previous mode into fuller expression or change in the next.

I chant and sing to concentrate emotion and devotion and ride the waves of those feelings, into my next act.

I dance when I feel paralyzed by a trapped emotion—wounded and stiff...catatonic. It helps me let go of the pain, and return to the world of the living again...

I write in my journal when I feel scattered or when I'm working out my relationships...It helps me to perceive the narrative in my life, when I've lost the sense of what story I am living, and why...

I write poems as a form of magic—to reshape patterns of being and look deeper into the mystery...

I cook when too many people, projects or things pull at me. When I cook, I stop thinking and start assimilating. It all gets thrown into the pot and boiled until it's soup. Then I eat it, and feel empowered to deal with everyone again.

...I paint to externalize, identify and talk with felt states and subjects of intense contemplation...I paint until an order, a form emerges that is coherent and catalytic...

I love drumming with people—the surrender to communication through rhythm is invigorating and ecstatic...

I live in my "art." It transports and defines me. It is a way for me to focus, contain and see through my desires— to dance with them, so I can touch people without being overwhelmed...

Art digests me and makes me accessible to the world. I cannot imagine being digested by only one or two modes of art. I want to be feasted upon by all of the heavenly powers—to be a tasty dish at the intermodal feasts of the gods!

Margaret Schneider, 1993
Lesley College graduate student
on her preferences for artistic disciplines

FOREWORD

Throughout the past decade, I have urged Paolo Knill to write a book about his practice of expressive therapy. Since the late 1970s, I have watched graduate students purchase bound photocopies of his doctoral dissertation, which until now was the only English text available on the subject he invented, intermodal expressive therapy. Paolo's book *Ausdruckstherapie* (1979) was published in his mother tongue, but American, Canadian and Israeli students had to settle for the Copyquick prototype. I said, "Paolo, we know the book will sell. There is a demonstrated need, and a clear desire for the information. You've got to write a real book in English about this work."

Now we have a text which presents the original theory and practice of intermodal expressive therapy together with recent reflections on imagination and play, aesthetics, research through the arts, and concepts like effective reality which expand an integrated approach to the arts in therapy. Paolo's collaboration with Helen Nienhaus Barba and Margo Fuchs provided the impetus for the completion of this opus, and the team effort shines through every one of its polished pages.

In founding the Institute for the Arts and Human Development in March of 1974 at the Lesley College Graduate School in Cambridge, Massachusetts, I began with the idea that we needed a masters training program in creative arts therapy modeled on the classical tradition of liberal learning. We emphasized depth through breadth and a comprehensive commitment to the full spectrum of expression. We felt that since our patients and students were constantly expressing themselves through different media, it made good sense to train ourselves to meet them where they were. We instinctively knew that the vitality of imagination was furthered through the engagement of all expressive faculties. Since opportunities for this type of study did not exist at any other school, we felt ourselves charged with a mission.

In my first months of gathering a faculty, I was introduced to Paolo Knill, then a visiting professor at Tufts University where he taught music from the perspective of Piaget. He was offering a similar course at Lesley, and when I told him about my ideas for a multidisciplinary expressive therapy program, he took to them like a duck to water. His response was validating to me, and through my twenty-year relationship with Paolo, he continued his total support for my incurable tendency to carve out new ways of doing and thinking about things.

In those early days, I felt that the Arts Institute's philosophy of *Gesamtkunstwerk,* or total expression, was an external manifestation of a beloved image that Paolo carried in his soul, waiting to be realized. His multi-disciplinary background as a graduate of the Swiss Institute of Technology, a musician, performance artist, educational psychologist and manager did not fit the specialization doctrines of our contemporary professions. His daimon was committed to many things, *viele Dinge,* and

the classical European ideal of discourse amongst various perspectives. But his most essential contribution to the formation of our community and the profession of expressive therapy was an infusion of the magic that permeates his being. I do not want to appear sentimental or unspecific, but anyone who has worked with Paolo knows how he evokes sacred and enchanting qualities loaded with medicine. This is the core method of expressive therapy practice, something distinctly present yet outside the scope of explaining. The discipline is a practice of a sacred presence.

This is the vision which holds us together and clearly distinguishes our methods from those who try to graft the arts onto branches of behavioral science and medical model therapies. Artists can certainly collaborate with therapists from every conceivable discipline, but the distinct qualities of artistic medicine must be strengthened rather than diluted.

It is intriguing how many who mix specific art disciplines with medical model therapies argue that integration of the arts will water down the individual components. I think they are doing something that they call projection, placing their own undesirable or unacknowledged traits onto someone else. From history, we see that the arts have always nourished and deepened one another. The more the individual disciplines cross-pollinate, the more vital they become.

Although Helen, Margo, Paolo and I share values of soulwork, our ways of operating have always been distinctly different. This individuation of the details of practice within a mutual ideal is an important point to emphasize to the therapist in training. The best advice I can give to any beginning or trained therapist is to encourage a careful reading of this historic and essential text, but then transform it with your own interpretations and contributions. This artistic philosophy of constant tran-

substantiation is what distinguishes our tradition from others which institutionalize their experience through a literal reading and following of a text. I cannot conceive of anything more fundamental to the efforts of Helen, Margo and Paolo than a sustained contagion of imagination from their practice to yours, and then onward from you to others, and perhaps back to them. It is a spiral movement of unpredictable influences, and not a linear progression.

One expressive arts therapist might plan experiences or rituals, and after the scheme is put into action, the initiator stands back to let it emerge according to its inner purpose. Others, or the person I just mentioned who may want to introduce a different *modus operandi*, may feel that the materials, the place and the forces operating in the individual and group psyches are in themselves more than enough inspiration and structure. In one session, there may be an integrated use of all of the arts into what Paolo has called "intermodal" practice; in another, I might paint only to paint, drum to drum, and dance to dance. I cannot overemphasize this necessary variety and spontaneous sense of direction characterizing *Minstrels of Soul*. The images and expressions move through us like angels and demons who know their way. They are the agents of imagination's medicine, which treats disorders of the soul with soul.

Margo Fuchs and Helen Barba, together with other leading practitioners such as Steve Levine, have carried expressive therapy into a new generation of creations. They have studied Paolo's methods, which have been rigorously tested over the past twenty years, and they have placed their personal spins on the work. They have helped to solidify the discipline as a major mode of clinical practice.

As I reflect back on the history of the first generation of experimentation, I must mention Norma Canner, who

was the muse and senior guide who helped Paolo and me shape a common purpose. She was always loving and holding the community of our efforts in a family way, while constantly expanding her own work with dance and movement to include voice, poetry, music, drama, visual imagery and body-oriented psychotherapy. Norma was the most active learner in our group, and she modeled how realization of the ideals of multidisciplinary creative arts therapy required a commitment to lifelong education, constant opening and new challenges.

Where Paolo, Norma and I came together as agents of a vision, Margo and Helen represent the next wave of thousands who went out from our graduate training program to do the work. When reading the manuscript for this book, I feel the presence of all those people and their creations. *Minstrels of Soul* is a gathering of creative spirits. In addition to the vital presence of the authors, the community of creation includes all of the arts and their offspring, the therapists trained in this tradition, and the people and places throughout the world who have received their services. This book embodies and celebrates an international movement which is to be acknowledged, and then encouraged to proudly take its place in the histories of psychotherapy and art. Those of us who have witnessed the creations must tell, sing, dance and paint the story forward through a community which preserves and honors our traditions.

Expressive therapy is a discipline of soul's contagion. It comes upon us daimonically through the agency of imagination, whose medicines draw from the full spectrum of soul. The work flourishes in settings which respect the taking of risks and which establish a deep sense of safety through a *participation mystique* resonating with soul's purpose and wisdom. We need *Minstrels of Soul* to help us dance freely outside the boundaries of anti-imaginal specializations that Edith Cobb (1977) felt threaten the

existence of a species.

I see similarities between intermodal expressive therapy and the Hellenic pantheon where the varieties were acknowledged and given their particular places. The Greek myths teach that after being enshrined in their temples, the gods and goddesses constantly cross fences. They are the polymorphous perversity of soul which cannot be controlled by a single vision or story. They teach us how everything is changing places, and this movement is the basis of life. Expressive therapy is a making of soul that never stops, and forever takes on new forms within the invisible pantheon that holds us all.

Palmerston Press is to be congratulated for its second major text on expressive therapy. This book joins Steve Levine's *Poiesis*, and I look forward to the ones which will follow from within our community. We are a collection of creators who do not want a progeny of exact likeness, which is not possible anyway. So why try to live with this illusion? In keeping with the advice of William Blake, I urge readers to study this magnificent discipline of intermodal expressive therapy, and then affirm its impact on your life by establishing your own system or anti-system that will give life back to the ecology of soul that is making us. I cannot think of anything that could be more pleasing to the creators of intermodal expressive therapy.

Shaun McNiff
Gloucester, Massachusetts

References:

Cobb, Edith. 1993. *The Ecology of Imagination in Childhood* (1977). Dallas, Spring Publications.

Knill, Paolo. 1979. *Ausdruckstherapie*. Lilienthal, Germany, ERES.

Levine, Stephen K. 1992. *Poiesis: The Language of Psychology and the Speech of the Soul*. Toronto, Palmerston Press.

INTRODUCTION:

Art as a Discipline of Diversity

Most practitioners today who actively incorporate the arts into the practice of psychotherapy find themselves divided into schools and associations based on their choice of artistic discipline. Some of the more popular and organized disciplines include music therapy, art therapy, dance therapy, drama therapy and poetry therapy.[1] When therapists "cross over" and draw on multiple disciplines, as they do in the field of expressive therapy,[2] they can meet with opposition from their differently-focused peers.

The controversy on one side appears to be rooted in a concern about the competence of practitioners who "spread themselves too thin." Mastery of *each* artistic discipline requires a lifetime of study and practice, so the argument goes; how could a therapist hope to master *several?* Art therapist Gladys Agell (1982) put it this way: "A flirtation with materials is not enough. Only a love affair with materials can lead to a wedding of felt experience and formed expression."

The arguments in this ongoing debate which favor specialization by artistic discipline are certainly reason-

able—*in view of the context from which they emerge.* We hope to present an *entirely different context,* a different way of looking at the arts in psychotherapy—one which finds its foundation in the age-old *tradition of multiplicity* in the practice of the arts—the "Great Manifold which serves oneness."

"Intermodal" expressive therapy neither requires nor promotes the mastery of several distinct schools of therapy, each of which finds focus in a single artistic discipline. Rather, it finds its primary focus in the *artistic tradition* which all the arts have in common. In other words, intermodal expressive therapy *is a discipline unto itself,* with its own theoretical framework and focus. As such, it avoids the *pitfalls* of specialization, as illustrated by Abraham Maslow, who said, "If the only tool you have is a hammer, every problem starts to look like a nail" (quoted by LeBoef, 1988, p. 28).

The need for integrating the art disciplines and arguments for moving the profession in this direction in both theory and practice have been well-documented by Knill (1979), McNiff (1981), Levine (1992) and Rogers (1993). What has *not* been sufficiently addressed in the literature is *intermodal theory,* including its philosophical foundations and its pertinence to the practice of expressive therapy. The goal of the text contained herein is to better articulate this body of knowledge.

The artistic tradition that provides a basic foundation for the development of the discipline of intermodal expressive therapy is rooted in human imagination and characterized by an interrelatedness among the arts. It is the same tradition in which performance artists, film-makers, choreographers, theater and opera directors need to train and gain eloquence. It is only fair that we also consider here the minstrels, storytellers and tribal artists throughout history who found no reason to divide their work into specializations according to particular artistic dis-

ciplines. It was in fact the multimodal nature of the work of minstrels—those versatile performers who not only mastered a multitude of manifestations of the arts, but who also touched the hearts of the people for whom they performed—that inspired the title of this book.

In many cases, of course, the mastery those artists achieved in their training and throughout their practice built upon one or more basic disciplines; however, from the moment they began their formal studio training they received a special interdisciplinary body of knowledge and skill that nurtured their sensitivity to the way an image finds its "scene" or "act"; to how it speaks most clearly through its rhythm, sounds or verbal messages. Performance artists may come from theater, visual art, music or dance or a mix of these disciplines, but in order to have a significant impact they need to learn the intermodal skills of the artistic tradition that may be framed by theories like crystallization theory and polyaesthetics, discussed below. Great directors of film and stage are not "Jacks of all trades"; they are *specialists in intermodal creativity*.

We do not presume that intermodal expressive therapists exist on the same level as these masters. This would be unfair, just as it would be unfair to compare a dance therapist with Harold Kreizberg or Mikhail Baryshnikov. What we *will* attempt to show is that there is a body of knowledge and skill concerned with an artistic tradition that connects the arts. We agree that it may help for an expressive therapist to build upon one or more basic disciplines and that training cannot consist of a mere conglomeration of arts therapies. Above all, however, we are advocating for a specialization in the interdisciplinary tradition of the arts.

To this end, we will endeavor to explain the nature of various artistic disciplines, how they interact and how they build a foundation for the development of skills that make movies, for example, so powerful as enhancers of

imagery through the way they combine and move between the modalities of action, posture and movement, visual images, sound, silence and words—skills which are similar to those the Shaman uses to make the dream or imagination speak. We will disclose, through an examination of research in the fields of music education, art history, anthropology, epistemology and aesthetics, how intermodal training can in fact enhance the mastery of specialized artistic disciplines at all levels of schooling.

Intermodal specialists have much to offer in the way of teaching and healing in our day and age, and we believe strongly in the value of intermodal training for a variety of practitioners.

Part One reviews the body of knowledge that pertains to the historical, interdisciplinary use of the arts in healing—a field which continues to evolve through ongoing, international discourse.

Part Two clarifies some key terms and examines our views of reality, distinguishing between imaginal and literal realities and exploring how "effective reality" emerges between the two. This discussion is relevant to the examination of beauty and of therapeutic implications to be discussed later.

Part Three enters intimately into a study of the *healing essence* of the arts. We will examine beauty, Eros and aggression as avenues towards understanding this essence.

Part Four focuses on applications and discusses the particulars of the practice of intermodal expressive therapy, including the therapeutic relationship and intermodal principles, methods and techniques in expressive therapy.

Part Five, finally, offers some thoughts, recommendations and encouragement concerning future research in the field of expressive therapy.

Notes on the Introduction

1 This is by no means a comprehensive list. In fact, the possibilities for using other artistic disciplines are limitless. Storytelling, photography, video – even folk art and food preparation – can and sometimes do play legitimate roles in the psychotherapeutic process.

2 In 1974, Lesley College began offering graduate training under the rubric, "Expressive Therapy." Since then both the California Institute of Integral Studies and the European Graduate School have developed graduate programs with the title, "Expressive Arts Therapy." We have retained the original formulation of "Intermodal Expressive Therapy" for the sake of consistency with the first edition of this book.

PART ONE

The Integrated Use of the Arts in the Healing of Psyche

The more she tells her story,
the more she can let go of it
As
she keeps changing the story
the story keeps changing her.

Our Story and Roots

L et us begin this section by examining its title: "Our Story and Roots." Though this examination may appear to be somewhat of a digression, it provides an important illustration of some key concepts relevant to the field we call *intermodal expressive therapy.*

Language, after all, is a powerful tool in intermodal expressive therapy. Too often expressive therapy has been incorrectly regarded as *nonverbal* therapy, thereby distinguished from other forms of psychotherapy. In fact, intermodal expressive therapy is both verbal and nonverbal. Moreover, by definition it eschews association with *any* single or group of artistic disciplines or modalities.[1]

The verbal communication of feelings and thoughts is a crucial part of any form of psychotherapy. But in intermodal expressive therapy the role of language extends beyond its popular use as a vehicle for explaining. Language is a vital part of the *artistic* disciplines used in the work. **Insofar as language enters our art, it also enters our interdisciplinary use of the arts in psychotherapy.**

So what of "Our Story and Roots"? The invitation to review our *story* prepares the reader for an imaginative—rather than literal—review of the events which precede our current place in time. To this end, we wish to point out that human memory functions most effectively in the imaginative realm.[2]

The operative word in this subtitle is, of course, "story." Storytelling is an age-old art form, and the text contained herein tells a few of the stories which led to the conceptualization of intermodal expressive therapy—stories of the integrated use of the arts in the healing of Psyche.

But before we begin the story-telling, let us examine the second part of our subtitle. The use of the term "roots" frames an understanding of these shared stories, lends them *form*. That form specifically evokes an image of living fibers which feed, nourish and support a tree or other form of vegetation—living, growing, reaching entities with integrity in their shape, yet with the space and potential to further stretch and be defined. The image emerges from a place deep in the earth. It is a grounding image. Notice how staying with this image enriches our understanding of the word's message. *Staying with the image*—or "sticking to the image," as recommended by Raphael López-Pedraza (as opposed to any single interpretation of it)—is a basic precept of intermodal expressive therapy.

Some of the oldest stories that contribute to our understanding of the interdisciplinary tradition in the

practice of the arts emerge from the field of anthropology. Anthropological studies show us how intimately the arts, play and imagination have been incorporated into human rituals. We will enter into our study of our anthropological roots, then, with an examination of the relationship between art, play and imagination. Following this discussion, we will share some specific theories pertinent to intermodal expressive therapy. Along these lines, it is interesting to note that the term which comes closest to the original meaning of *theory* (as "viewing") is phenomenology. Richard Palmer (1969), commenting on Heidegger's work, explains that according to Heidegger, "The very essence of true understanding is that of being led by the power of the thing...Phenomenology is a means of being led by the phenomenon" (p. 128). A phenomenological approach is basic and essential to the successful practice of intermodal expressive therapy and operates in concert with the other theories mentioned below, including crystallization theory, polyaesthetics, intermodal theory, and integration and separation.

Play and Art, Imagination and Soul

Art in its purest form is primarily a ritual activity that is practiced in an elaborate manner only by humans and has no evident "goal" other than celebrating creativity and human potential.[3] All the arts complement and interact with each other to unify play and imagination in a way that permits the celebration of our humanity. In order to deepen our appreciation of the arts' role in play and imagination, it may be helpful to begin by examining the origins of some key words.

Play

In our language, we are accustomed to using the word *play* when communicating about the arts. We might "play" music or musical instruments, for example, or attend a "play." The root of the word *play* can be found in the old Slavic *plesati* and the Gothic *plinsjan*, both meaning "to dance." In German, *spielen* refers back to the root *spil*, which we also find in Danish (*spille*) and Swedish (*spel*). Here again the etymological root means "dance"; "the stepping forward and backward and to the sides" and "to dance in a circle" (Kluge, 1975, p. 725).

Play relates closely to dance and to the image of a circle. This relationship helps to distinguish *play* from *game*, which in English relates to hunting. The terms *game* and *hunting* suggest a directional, linear, goal-oriented "walk"; the line towards the prey. The difference between the goal-oriented action of the game and the circular dance of play can be viewed as a difference in the structure of time, which is linear in the directed activities of a game, but circular in play (Lorenz, 1987, p. 395).

For those who play, the source of satisfaction lies in *the play itself*. In contrast, it is the *outcome* which is paramount in the game.

Play and dance are also closely connected with each other in religious traditions and in tribal shamanism, as we observe in the dance of masks, the medieval church play (e.g., the Play of Daniel), or the dancing of dervishes. Indeed, there is a sacred, worshipful quality in any activity which has no goal other than to be a playful manifestation of life, as when a tree plays with the wind or a child plays with her toes.

Imagination

It is instructive to examine the word *imagination*, since it is the nature of play to engage the imagination. When

we examine the roots of the word, we find the Latin *imaginatio*, its stem being *imago*. *Imago*, which may be translated as *image*, has a broader meaning. According to Meier, the linguistic paleolithic roots mean "in the water" or "the mirrored thing in the water." The word for imagination in Swedish (*inbilla*) and in ancient German (*inbilden*) originally meant, "to project into the soul." Soul and water, too, are closely related, as Heraclitus pointed out:

> *The soul procreated the substance from which dreams are made, and the arising images reflect in the human like trees in the swaying water* (Meier, 1988, p. 210).

We are accustomed in our visually oriented society to reducing imagination to visual images alone. Because we understand the term *image* in a visual way, we often neglect imagination's other sensory aspects. In fact, isn't it true that humans typically *imagine* not only visual images, but also sounds and rhythms, movements, acts, spoken messages and moving pictures—even tastes and tactile sensations? Imagination is the visiting place of soul, where the depth of Psyche is revealed.[4]

Consider dreams, where soul speaks through imagination. We may sense the *movement* of swimming or hear a voice sing or speak *words*; we may experience the *act* of killing or see a beautiful *visual image* of a city, or listen to the *sound* and *rhythm* of music. **Imagination is intermodal.**

The movements, words, visual images, acts, sounds and rhythms that we sense in a dream may be defined as *modalities of imagination.* We have no power over them; they are autonomous of us and arrive or do not arrive of their own intent, with or without verbal accompaniments.

Indeed, some people never experience spoken, verbal messages in their dreams—only images. The modalities may be interwoven or isolated. "Cutting down a tree" in a dream is an *act*, but it also conveys an *image* (of a tree or a saw), and a *movement* (that of sawing). In the experience, the act may have been the outstanding fact. On the other hand, when we hear a voice unaccompanied by a visual image, we might remember it as a verbal message alone; such is the nature of a single modality of imagination.

When we daydream, we have more power over the modalities of imagination. We follow a visual image in a guided imagination; yet, we may still meet surprises. We might seek the image of a particular animal, and be greeted by another who behaves in an unexpected manner or suddenly speaks a message. In other words, in daydreaming we have a sense of playing with imagination, whereas in dreaming we receive the material of imagination passively. In the disciplines of the arts, we approach the material with the will of a creator submitting to the realm of images, and actively shape it. The material and the surprising events that arrive through imagination call for our disciplined engagement in the arts.

The phenomenon of creativity truly distinguishes the human from other creatures that may dream and fantasize but do not engage in this miraculous activity that lends shape to imagination with will and discipline. Our creativity enables us to receive deep psychic material, struggle with and transform it. No wonder artistic creativity was always part of rituals for upholding or regaining health. Art and the creative act comprise a *primary* process which has, in fact, operated as one of the "continuities" in therapy and healing throughout the ages.[5]

Any art discipline, then, because of its connection with imagination, can evoke and find further expression in any

other modality imaginable. A poem, for instance, can evoke *visual images*, it has a *rhythm*, and it may find further power by describing an *act*. Heidegger (1977) put it this way: "Only image formed keeps the vision. Yet image formed rests in the poem." We think of poetry as a distinct art discipline, but on close examination we can clearly see how in tapping into imagination poetry taps into a multitude of modalities and may draw us into other forms of artistic expression. Similarly, a piece of music or a piece of theater, like a painting or novel, may contain any number of modalities perceivable by imagination: movements, acts, images, sounds, rhythms, words—and empty spaces.

In summary, anthropological studies reveal many stories of how cultures have used the arts imaginatively in their play and rituals. In rituals, the arts, when engaged, all flow together purposefully with a sense of oneness. It is this sense of unity, of oneness in the arts, that provides a focus in the study and practice of the interdisciplinary use of the arts in psychotherapy. Paradoxically, the *differentiation* of art disciplines and modalities becomes a vital part of the study as well. We may deepen our understanding of differentiation in the arts and implications for therapy through a study of crystallization theory. But first, let us examine the role of polyaesthetics in further enhancing our understanding of connections among the arts.

Polyaesthetics

In the 1950s Wolfgang Roscher—the celebrated German educator, musician and theater director—developed an interdisciplinary method for teaching music, theater, dance, literature and art. The intermodal improvisations and performances he facilitated were well received

and formed the basis for a training model that became duplicated in numerous European schools, colleges and conservatories. Roscher's theory of polyaesthetics was premised on the observation that all the art disciplines engage to some extent in all the sensory and communicative modalities. He found this to be true both in the perception of and the production of the arts. Musicians of this school require training and refinement of more than just the auditory faculties. A rhythmic awareness of dance, combined with visual competencies concerning structure, form and color or timbre—with a poetic sensitivity to musical phrasing and lyrics, and with an understanding of drama in the development of motifs—all become essential. This new polyaesthetics (Roscher, 1976) deepened the earlier research of Dalcroze (1921), the founder of Dalcroze Eurhythmics (Bachmann, 1991). Roscher extended applications into the realm of the arts and literature.

The traditional model of arts education which grew from Chinese culture also deserves mention. Within this model, the practice of philosophy, aesthetics, music and the visual arts—along with many other disciplines—existed as a *single* tradition. When it came to educating artists, students engaged in what we would call an interdisciplinary approach. Painters wrote poetry, often including beautifully executed characters within their paintings. Musicians studied all the arts. It has only been within the last several decades that these practices have changed in deference to artistic specialization.

Liao (1989, pp. 171-174) wrote that in his view the guiding principle of polyaesthetic education and therapy should not negate the specificity of the particular art disciplines; rather, it should promote the traditional wisdom that all the arts are members of one harmonic body. To educate in an integrated way, therefore, one must allow

a synthesis that sharpens the sensory modalities—an important competency for all artists. The human instinct is multisensory, Liao claimed. Visual senses do not exclude auditory ones, and auditory senses are reinforced by visual ones. The Chinese chef always considers perfection of color, aroma and taste simultaneously.

Today polyaesthetics is an established discipline taught in many Austrian and German institutions. Roscher himself currently directs a university institute specializing in polyaesthetics.[6]

Polyaesthetics sheds light on intermodal technique through its teachings on sensory perception. In dance, for example, it is taught that the ability to differentiate among movement structures corresponds with the development of sensorimotor intelligence. A sensorimotor experience of structure involves both time and space, and this means that the differentiation process in dance involves the exploration of images spatially *and* the exploration of sound temporally.

If we observe a child improvising a tree dance from the image of a seed to a magnificent, fully grown structure, we may note her measured timing in the slow change of the musical structure. Further, the piece will enable her not only to express the concepts of low and high, little and big, or small and tall; but also an understanding of becoming, emerging and growing as a tree. The comprehension of the time-space continuum, then, reaches from Piaget's sensorimotor to his concrete operational stage (Pulasky, 1971).

The material through which music is expressed is sound and silence. This material can be further differentiated according to the class or quality of sound, and also with regard to form or structure. The latter differentiation is facilitated through the visual and tactile senses. The tactile differentiation we learn by experiencing *smooth* silk,

for example, in comparison with the *sharp* edge of a stone helps us to understand the concept behind a slow, legato, (*smooth*) stream of sound from strings when they are suddenly interrupted—"*attacca*"—by a (*sharp*) drumbeat. Our ability to follow a musical figure in its up-and-down movement, or in its emergence from a dark sound into lightness, may be facilitated by engaging in painting, which can then facilitate the understanding of variation and modulation of figures in company with other musical elements and their development.

Language—namely, its structure and content in interpersonal exchanges—is similar to music, with its polyaesthetic differentiations. Verbal language structure develops along with the temporal distinctions of musical process and syntax, through the expressive and perceptive exploration of music. All these faculties together help us to understand meaning and content in music and poetry. A poem might be better understood when it is sung, since we access more information through more senses.

Polyaesthetics can in fact be applied to all the art disciplines, based on the distinctions of sensory modalities and considering developmental issues of perception, expression and cognition (Knill, 1979, pp. 47-48).

Crystallization Theory

Crystallization theory pertains to the basic human need or drive to crystallize psychic material; that is, to move towards optimal clarity and precision of feeling and thought. When material is effectively crystallized, we experience it as being fitting, clear, right and true. We have found that the arts are uniquely suited to assisting us in reaching nearer to crystallization as a therapeutic goal.

Put another way, in the metaphor of crystallization we observe how in an environment "saturated" with artistic imagination, a small creative act "grows," much like a seed grows. Through its growth, the seed's full meaning emerges with the clarity and order of a crystal. Crystallization theory helps us to formulate how to provide optimal conditions for emerging images to disclose their meanings with the help of the arts.

Crystallization Theory and Interpretation

Crystallization theory is built first and foremost upon the phenomenological premise that meaning in a psychotherapeutic encounter emerges exclusively from the material that comes forth between therapist and client as they relate with one another. Theories of transference and countertransference work under a similar assumption; however, they do not typically use the artistic process as the means to elucidate meaning, as is the case in intermodal expressive therapy. Crystallization theory interprets meaning phenomenologically, through artistic differentiation in a poesis[7] indigenous to art—that is, in words which are imaginative, particular and precise.

We are reminded here that poetic language is part of many art disciplines, including poetry, storytelling, songwriting, drama and fiction. Though thinking and imagination may often appear "divorced" from each other, they remain beautifully wed in poetry. Poetic interpretations enable us to find meaning in *context*, which reveals itself in a *text* delivered in the *language of imagination*.[8] Interpretation need not be a process of translating images, sounds, rhythms, acts, movements and words into a theoretical framework that lies outside the context, *foreign* to the arts—perhaps foreign even to the client and/or the therapist. Rather, within crystallization theory, a psychological theory imposed from outside the persons engaged

in the here-and-now of the situation might be investigated as a disturbing background conversation, a kind of countertransference.

Communication Modalities

Among all art disciplines we find a variety of sensory and communication modalities. Within the visual arts, for instance, we know that sensorimotor and tactile senses are engaged when we paint. We know that a painting communicates not only through the visual image, but also through the *rhythm* of color. And a painting may evoke a *story* that depicts an *act.*

Music engages not only the auditory sense, but also the sensorimotor, tactile and visual faculties. It communicates by means of rhythm and sound, and through words/lyrics that may evoke strong visual images.

Notwithstanding the interdisciplinary nature of the arts, it is instructive to distinguish the various disciplines according to the sensory modalities they seem to prefer. These distinctions are particularly important in polyaesthetics, discussed above. To summarize briefly for now, the following disciplines show certain preferences for engaging the senses indicated:

- ♦ **visual arts** — visual;
- ♦ **music** — auditory;
- ♦ **dance** — sensorimotor;
- ♦ **literature** and **poetry** — auditory and visual; and
- ♦ **theater** — auditory, sensorimotor and visual.

Modalities of Imagination

Like polyaesthetics, crystallization theory makes distinctions between the modalities of imagination (including visual images, movement, sound, rhythm, action, and so

on). Historically each of the art disciplines, as vehicles for imagination, have provided containers for clarification, using one of the modalities of imagination within its respective tradition in unique ways. For example:

♦ One can talk, dream or write about visual images, but *visual images* crystallize most clearly in a *picture* or *sculpture*. **There is no visual art without visual images**.

♦ One can be moved through music, a story or a scene; or one can describe an act through *motion* pictures; but *movement* is experienced best through its crystallization in dance. **There is no dance without movement.**

♦ One may tell, write, sing, or paint about *actions*, but the most impressive format for demonstrating an action is on stage in a scene, as in *theater*. **There is no theater without action.**

♦ One may move, walk or talk rhythmically or communicate with sounds, whistles or moans, but we most intensely experience *sound* and *rhythm*s that are crystallized in *music*. **There is no music without sound and rhythm.**

♦ One may use words to convey visual imagery or to narrate scenes or dramatic movements, but *words* are most accentuated as a poetic component in the telling of a story or the writing of a *poem*. **There is no poetry without words.**

These observations direct us to the fact that we also communicate through a variety of modalities, not only limited to talk or gesture, without the intention of doing

any "art" *per se.* We communicate, therefore, through modalities of imagination, including visual images; posture and movement; sound, silence and rhythm; words; and actions.

Crystallization Theory and the Performance Artist

Each discipline that uses the arts in psychotherapy can inform the others in the understanding and mastery of modalities. The poet learns from the musician or dancer about rhythm. The painter may learn from the actor about scenes, time and space in relation to an act. The dancer may learn from the sculptor how to dialogue with an image coming up in a dance.

These are a few examples. But before ending our list, we need to mention one particular type of artist who takes on growing importance in our current age, which has been characterized by a veritable "media explosion." This is the performance artist, the video- and movie-maker and, in the same class, the intermodal expressive therapist.

All artists have much to learn from these intermodal specialists—namely, about crystallization theory and intermodal technique. A close look at many television productions will reveal that a knowledge of crystallization theory—upon which intermodal techniques are based, in part—and the skills involved in using intermodal techniques—are required by anyone who wishes to master video, the most consumed medium of our day. This base of knowledge and skills enables the medium to so effectively "push our buttons," to influence us in ways that may even prompt us to change our behavior. Advertising "masterpieces," incorporating an expert ability to combine just the right modalities in just the right way, unfailingly manipulate us to purchase products for which we may otherwise have no use.

The arts touch our humanity, and their power has been exceedingly helpful in therapeutic situations. It has been our experience that nothing works as well as intermodal skills when it comes to helping people in therapy to clarify issues and feelings. On a broader scale, the same skills may be useful in addressing a culture whose art seems to have become increasingly abused and contaminated with sickening qualities. A greater intermodal "literacy" could promote a more critical awareness of our media and arts, enabling us to become active participants rather than helpless victims of the media to which we are all exposed.

To recover the ancient intermodal theory underlying the discipline of performance art, video and film, we need to re-search the word, image, rhythm, sound, movement and act. When we approach this study in terms of crystallization theory, we concern ourselves with whatever communication modalities patients or clients might choose.

Often, the choice is not stated openly, but a modality or modalities manifest in conversational language and gestures. A strong gesture, using arms and torso with a statement like, "The opportunities *fly* by so *fast*, I am always too late; I cannot *run* after them!" seems to suggest *movement.* Another statement might suggest more *visual* imagery, "They are like *birds*; I need a *net* to catch them." Or sound and rhythm might be implied as a more useful avenue in a statement like, "They never *dance* to my *tune*, and I cannot *tune* into their *music.*"

Verbal conversation is, of course, one of the possible choices of modality. In therapy, the verbal sharing of a dream may be a useful way to proceed. The description might imply strong movements or a major act that could call for expression by way of a dance or theatrical enactment. Or the therapist may suggest painting the dream as an appropriate first step, in order to allow distance and time to explore the space and thereby enable the person to sense precisely where the image might want to find its

crystallization. It is not unheard of that a therapist's first probe or intervention will prove to be an awkward path for crystallization. But that is not to say that after the painting or dancing of a dream, a more meaningful context cannot still emerge in a story or poem.

Intermodal Sensitivity and Presence

Intermodal training refines the therapist's intuitive presence in the process of crystallization, and in the therapeutic process. This training must include study of the theories (namely, polyaesthetics and intermodal theories) which support the development of a keen sensitivity to modalities of the imagination in conversation and in the arts. Effective training in this form of sensitivity requires the refinement of observational skills as well as the practice of the arts and their transformation into performing art disciplines.

Intermodal Transfer and Superimposition

The intermodal transfer—that is, the shifting from one art form to another—is another artistic skill with which performance artists are innately familiar, due to the interdisciplinary nature of their work. The fundamental aesthetic criteria for choices in the design of performance art is the enhancement of an imagination modality. A therapist might ask the client, for example, "What kind of sound or rhythm supports the planned act?" "Maybe we should leave it in silence and add an image on the backdrop?" "No —a blackout and a poetic description of the act is more effective!" These sorts of interventions are typical of decision-making among performance artists and movie-makers. In therapy, the skill serves the emotional process of clarification. An intermodal transfer supports the focusing process, revealing the "quite right" image, movement, sound and rhythm, or word. The process dis-

closes the "felt sense"[9] (Gendlin, 1981) and can allow for insight or a "shift" in awareness.

The eventual transfer to the poetic discipline deserves special mention. To crystallize finally to a poetic activity allows images, acts, movements, rhythm or sounds to find a *cognitive sense* in poetic words. As we are "taken" by images, the poetic gate opens, and surprise guides us through. Poetry embodies the soul of new thought.

As we indicated earlier, interpretation need not be a translation into a psychotherapeutic theory foreign to the shared experience of the artistic process. McNiff's sense of interpretation as accessing the expression of the image is apparent in his position against "image abuse" (1988) and culminates in his work on "dialoguing" with images. We promote following the path of an *act, movement* or *sound and rhythm* in the same manner as one might follow a visual image. We believe that interpretation works best as a creative dialogue through various artistic modes until they are ready for cognitive crystallization *par excellence*, through the art of language.

Intermodal Theory

Within the practice of psychotherapy, the natural use of varied *modalities* (e.g., image, sound and rhythm, movement, words, and action), combined with the popularity of using *art disciplines* (e.g., visual art, music, dance, literature and theater) made the development of an intermodal theory inevitable. With this development, the investigation of the arts and their qualities in the therapeutic process has become the focal point of many practitioners and educators.

Important research contributed by Decker-Voigt in Europe helped to resolve the concern addressed earlier, regarding the "unskilled mixing" of methods of art, dance,

music and drama therapies (1975). His investigation of modalities of expression and perception in education, special education and psychotherapy was based on the study of the intermodal aspects of music, as is demonstrated in the intertwining of lyrics, rhythm, movement and action. This work further influenced the research of Frohne in Germany (1983) and authors in the United States.

In the early seventies Shaun McNiff at Lesley College initiated the first intermodal expressive therapy training group in the United States, under the auspices of the Institute for the Arts and Human Development. He based his inquiry on clinical experiences with what he called "total expression" (McNiff, 1981, pp. xix-xxi). In collaboration with the Lesley College faculty and affiliated training programs in Europe, a theory was formulated for the integrated use of the arts in psychotherapy (Knill, 1979; Decker-Voigt, 1980; McNiff, 1981 and 1987; Fuchs, 1987; Levine, 1992). A theory emerged from this early work that distinguishes between interpersonal, intrapersonal, transpersonal and synesthetic considerations.

Interpersonal Considerations

Interpersonal considerations take into account what we understand about group dynamics within the artistic process. The arts regulate in their tradition the communication between members of a group; specifically, they offer the restrictions of structure and form, and also facilitate certain interactions which are difficult to duplicate outside the artistic forms. In other words, they can enable a group's dynamic to become more *visible* or *audible*, or they might encourage the dynamic through enactment or choreography. Moreno (1959) recognized this ability of the arts in his practice of sociometry.

When we compare in our intermodal practice the various disciplines of art expression, we find differences between them. Painting and sculpting, because of their inherent conduciveness to private, isolated work, lend themselves readily to the process of individuation. Music, with its resounding, inescapable presence, lends itself more naturally to socialization. Dance and movement, on the other hand, create opportunities for exploring relationships and coalitions within a group. Clinicians who make use of all these disciplines (and more) require special training in the interdisciplinary use of the arts in therapy. Of particular importance here are an understanding and ability to engage such methods or techniques as intermodal transfer and intermodal superimposition. Part Four addresses the practical application of these techniques. For now, suffice it to say that research has shown that these techniques serve to deepen or extend expression, intensify or amplify group involvement or individuation, and offer less threatening modes for finding words beyond those habitually used in conversation.

Intrapersonal Considerations

Key intrapersonal considerations refer to the acquired emotional attitude of an individual or a collective toward a particular discipline of art expression. For example, certain people bring a great resistance to spontaneous expression through music, sometimes in response to performance anxiety related to formal training. And certain cultures discourage spontaneous acting, for example, which could appear to disrupt the social order. Many of us prefer or feel more at ease with particular forms of artistic expression than with others, and these preferences may vary according to circumstances.

The poetic musings of student Margaret Schneider in the preface of this work illustrate one person's preferences

for various modalities. Knill elaborates his own preferences by disclosing these personal observations:

> Looking at myself and my habits, I find that I am accustomed to drawing a picture when I seek to convey an idea with clarity and accuracy—for example, when giving directions to my house.
> When I want to demonstrate something without long-winded comments and explanation, I use the magic of theater. I might impersonate my grandmother with my voice and a characteristic gesticulation, imitating her shrieking call for the chickens— a shriek that sounded like a raven early in the morning, waking everyone on the farm.
> When I express myself through poetry I experience intense vulnerability. On my 52nd birthday, I wrote:

> *Yes, my age, my age*
> *is like the moss on the tree trunk*
> *dewed with tears*
> *yes, and my pride, my pride*
> *is tumbling like the leaves in autumn*
> *shielding the gentle green from winter*
> *soon approaching*

Transpersonal Considerations

Transpersonal considerations evolve from the traditions of the spiritual, religious and ritualistic use of the arts. Pictures, sculptures and symbolic objects mark the place of worship and are like openings, doorways or windows to the sacred, the realm of spirits and gods. Instead of keeping a painting of a patient in a drawer, it may serve as a vehicle for an ongoing spiritual dialogue when it is hung altar-like in the bedroom.[10] A sculpture of a client

may want to be placed at the entrance of her house, giving a sense of protection or reminding her with each homecoming to leave something of the day's burden outside as an offering at this "totem pole."

Great prayers traditionally are also great poems and do not lose their power through repetition. In fact, it is the repetition that reaffirms the experience and makes it "known by *heart*." Such spiritual power is in every touching poem. Who has not taken the time to read the love poem from a dear friend over and over again, renewing a deep emotional experience with each reading? It is good practice in psychotherapy, therefore, to encourage the repetitive (e.g., assigning as homework the daily reading of a poem or story that emerged in a significant session).

Dance and music are united in many religious practices. Usually the dance builds a bridge to theater-like enactments, often with costumes or masks, while the music connects the dancer through songs and hymns to the sacred. The repetitive enactment of an important spiritual event (for example, initiation, blessing, redemption, conjuring or empowerment) is experienced in dance and theatrical containers. It would then make sense that for some patients the sessions could always start with remembering an important psychic event through a dance-theater, or ending the session with an enactment of a blessing. Music, and especially the song, has the characteristic of calling or praising higher powers. As an "inner" music, it can accompany us like a positive "ear worm" and surface unexpectedly in situations where it is helpful, sometimes entering our voice when we sing or whistle. Often, we are surprised about the emotional shift that accompanies it.

Using the arts in psychotherapy without considering the archetypal powers connected with them—and without fostering our clients' sensitivity and practice of it—

means to forget one of the basic human instincts towards health and the sacred.

Synesthetic Considerations

We are accustomed in our contemporary society to experiencing the arts as separate. We "see" paintings, "listen to" concerts, and "read" poems. But if we carefully consider the ways in which we experience or participate in the arts, their inherent intermodal natures become more apparent. Isn't it true, for example, that when we express ourselves with music, we not only make sounds, but we also move and create a visual image with our bodies and instruments in space?[11] And when are we not "moved" by poetry and "touched" by paintings? As Marks (1978) points out,

> *Sensory correspondence is not a domain of inquiry restricted to scientists, a matter solely for experimental scrutiny and empirically based theory. The plain fact is that sensory analogies do exist; they are important to the ways that we sense, perceive and cognize; they are significant properties of the bodies and minds of people"* (p. 7).

These sensory correspondences fall under the rubric of *synesthesia*. Synesthesia is a term that refers to the simultaneous perception of more than one sense through a single sense.[12] The most common form is "visual hearing," where sounds are experienced as colors. Relatively few people are truly synesthetic, and often their associations will differ (a particular musical tone may produce the experience of different colors for different people, for example). Nevertheless, for the most part synesthetic phenomena seem to originate out of an appreciation for the closeness and richness of various

sensory qualities, and these, we feel, originate from our human experience of the world.

Let us examine, for example, our human experience of "O" (pronounced "oh"). It possesses a visual roundness, a sense of wholeness and smoothness. If we *sculpt* it to give it added dimension, we would universally experience a circle or sphere. The *sound* of "oh" has a roundness as well—we form our lips into a circular shape in order to generate the sound. The shape of "O" is symbolic of oneness, closure and even spiritual wholeness, as in Jung's use of mandalas; and the sound begins the familiar meditation chant, "Ohm." If we *dance* in a circle with others, we experience a kind of oneness, and probably a feeling of safety as well. And when we look to our culture, we find other symbols of oneness, such as the wedding ring.

Innumerable other examples exist. Further, many suggestions of synesthetic phenomena appear in our everyday language. Consider "bright" colors, sounds and tastes; "warm" and "cool" materials, feelings and colors. Consider also the examples of poetic simile, like Rudyard Kipling's "The dawn comes up like thunder." In the words of Kathleen Hjerter (1986), "The tools are allied, the impulse is one" (p. 8). Certain disciplines, in fact, like opera and ballet, are intrinsically synesthetic forms of expression. Richard Wagner [1813-1883] was very much aware of this phenomenon and, following the ideas of the philosophers Feuerbach and Schopenhauer, he coined the term *"Gesamtkunstwerk"* (meaning "total work of art") to describe it. He conceived of the *Gesamtkunstwerk* as a synthesis of all the arts, and he practiced the discipline by not only composing his own music and writing his own texts, but also designing stages and opera houses and choreographing and directing his work. His goal was "total art expression under the supremacy of poetry" (Szeemann, 1983).

It very nearly goes without saying that feelings can be experienced with all the art forms, though it might be argued that certain art forms are more conducive to particular expressions than others. The following section examines the criterion of conduciveness.

Working with Particular Sensory Modalities

Having acknowledged the "unity of the senses," it is essential for a thorough understanding of intermodal expressive therapy to also examine the different ways in which we perceive the various sensory modalities. The following table outlines some of these differences.

Note that the table discloses the sensory conduciveness of each art form or discipline during expression (indicated by the items in bold), as well as the number of various senses engaged.[13]

ART FORM	Sensory modality traditionally engaged during expression	Sensory modality traditionally engaged during perception
painting, drawing	**visual** sensorimotor	visual
sculpture	tactile, **visual**, sensorimotor	visual; tactile & sensorimotor if permitted by exhibitor
music	**auditory**, visual sensorimotor	auditory *(recordings)* visual *(TV, concerts)* sensorimotor *(dance)*
dance	**sensorimotor**, visual, auditory	visual, auditory; sensorimotor when dancing with others
poetry, prose literature,	**verbal representation** of auditory and visual	auditory *(recital)* visual *(reading)*
theater, opera	**auditory, visual, sensorimotor**	auditory, visual

These preferences suggest the most *essential* means of communicating through the arts. However, we must not forget that:

♦ Within the visual arts, we can *speak, move, sound* and *act* through visual images.

♦ Within dance, we can *imagine, speak, sound* and *act* through movement.

♦ Within theater, we can *speak, imagine, sound* and *move* through actions.

♦ Within music, we can *speak, imagine, move, sound* and *act* through sound and rhythm.

♦ Within literature, we can *imagine, move, sound* and *act* through the word.

The conduciveness of modalities for expression, communication and perception always influence one's choice of art form in an expression, even though the influence may be working beneath our awareness.

One provocative example pertinent to the work of psychotherapists relates to autobiographical material. The senses are the vehicles through which our histories are recorded. Consequently, memory is not exclusively verbal, nor is it restricted to the domain of the brain. Autobiography is an essential aspect of many psychotherapies, and in many cases (e.g., with pre-verbal memories or in examples of severe trauma), it may be best achieved through channels other than verbal ones. Memories may in fact emerge in response to touch or carefully guided body movements. Or, they may reveal themselves in visual images which allow for a more distanced and

even cryptic view, in a manner more easily tolerated than direct confrontation with a verbal recounting of the story. This can move an individual in small, easier ways to manage steps towards understanding and healing.

Therapeutic Aspects of Particular Art Disciplines

One way to summarize the therapeutic aspects of particular art disciplines is to examine the three considerations of intermodal theory mentioned earlier—interpersonal, intrapersonal and transpersonal—and how the various modalities contribute to the experiencing of each. The schematic presentation below illustrates the interactional relationship between these three levels of relating, and the table following links them with their most conducive art disciplines.

```
                    intrapersonal
                    individuation
                    self-realization

interpersonal                        transpersonal
socialization                        universality
self-actualization                   transformation
```

Art Discipline	Lends itself most readily to:	Can alternatively be used for:
painting, drawing poetry, prose	individuation	socialization (e.g., via a group painting or writing activity)
music	socialization	*individuation* (e.g., in a solo structure)
movement/dance theatre	both socialization and individuation	(One aspect may dominate, depending on the structure)

- 46 -

Needless to say, *every* creative act offers opportunities to experience universality and transformation. We might also approach a study of the therapeutic aspects of particular art disciplines by reframing our understanding of the therapeutic process to examine the different *functional* phases of therapy. We have named them as follows: centering and individuation, expression and catharsis, containment and documentation, meaning and sense-making, and communication and communion.[14] We will address each separately.

Centering and Individuation

Centering refers to the therapeutic process of finding out what is going on in one's organism, body and mind. There are a wide range of structures for achieving this, including meditative techniques and relaxation exercises. The arts serve beautifully to assist the meditative, centering process. Those which are most conducive to this tend to be *individuating* activities.

The most effective art form for centering is that with which one feels a high level of comfort, *and* that which can be done in private, such as drawing, writing, or performing a solo improvisation on an instrument.

In groups, only visual art and writing allow for the experience of separateness. Any other disciplines tend to promote communication or communion, which is addressed in more depth below.

Expression and Catharsis

Offering people a means of *expression* is a fundamental function of the arts in therapy. Whether one pursues the expression of feelings, of conflict, of the unconscious, of self, or of soul depends upon the theoretical orientation of the artist and/or therapist involved.[15]

Expressing material, bringing it out, making it present can be a cathartic experience for many. The kind of "expression" implied in a cathartic process might be compared with the experience of release from constipation. If we follow the metaphor through, we gain a greater appreciation of the function of catharsis as a cleansing process, which involves a letting go of "shit."[16] We also confront some significant questions regarding its value and/or function, such as:

Is catharsis a natural phenomenon in therapy; or is it a tool to be applied only in certain situations?

♦ If it is a natural phenomenon, is its absence diagnostic of deviations or disturbances that require treatment?

♦ If it is a tool, what are the indications for it?

♦ If catharsis is not induced, might one expect a detrimental effect (i.e., poisoning through constipation)? Or are there other means of cleansing (such as purification through prayer and other religious rituals)?

♦ By the same token, is there not an equal potential danger in encouraging an excess of catharsis (i.e., depletion of essential fluids via diarrhea)?

The expressive therapist working with a sense of aesthetic responsibility will take all these questions into consideration before prescribing or promoting a cathartic experience, though the name "expressive therapy" may seem to indicate otherwise. Expression is only a *part* of an expressive therapist's repertoire of therapeutic interventions.

Nevertheless, an expressive therapist may judge in certain situations that catharsis is an essential "first step"

to working through therapeutic material. The arts, then, can enhance the depth and intensity of the catharsis by engaging human sensation in the experience—and containment of the expression.

Those art disciplines which enable the most profound cathartic experiences, understandably, are those which engage the body itself and the optimal number of senses. What can be more cathartic than experiencing one's body, voice and physical sensation engaged in a cathartic scream, as in a drama or voice and movement improvisation? It appears that the use of space, movement and flow is freeing and facilitates spontaneity. Moreover, there is more intense engagement of the organism as a whole, which may steer the person from reflective censoring in the expressive opening.

All the arts, of course, can serve the purpose of catharsis. Even the comparatively sedentary activity of painting a visual image can evoke a cathartic structure, especially if emphasis is placed on the use of space, movement and flow. This may hold particularly true for people who lack full mobility or have limited access to other senses.

Containment and Documentation

It's important to remember, of course, that the value of the arts in therapy does not stop here. Once we have accessed depth, it ordinarily needs further attention in order to enable an enhanced understanding and/or to move towards change and transformation. The understanding of an experience begins with its *containment.*

The arts are supremely suited to containing material—again, some more than others. The most effective "containers" are those which can be held still in time and space: visual art and sculpture, for example. In a cathartic moment, a dance or song may adequately hold or

contain a wealth of therapeutic material, but it can never be truly captured for further reflection and examination in the same way that it may be held within a visual/physical container. The nature of sound and movement is to travel through time and space, and even if one captures it via an electronic recording or a written documentation, the container still stretches across a time/space continuum: we cannot experience beginning, middle and end simultaneously. This in turn limits our ability to distance ourselves in our reflections upon the material and images evoked.

One of the things that makes intermodal expressive therapy so useful is the premise that the same material can be channeled into any number of modalities or art disciplines. That is, once we have danced, for example, we can further document the experience by writing a story or building a sculpture. In the process, we don't lose the initial images, we simply deepen and enrich them.

Meaning and Sense-Making

A logical next step in the therapeutic process, after a possible catharsis and containment, is the inherent, human desire or need to *make sense* of the emergent, to find *meaning* in it.

It is our conviction that the most therapeutic way to proceed with the quest for meaning is to permit an ongoing, imaginative exploration of material that enables the deepening of images and the enrichment of meaning, versus limiting our understanding by attributing a single interpretation or restrictive label to something.

The modality that seems most conducive to sense-making is a verbal modality like creative writing; for example, poetry. Poetry has the capacity to elaborate and explain in an imaginative way characterized by precision and particularity. Poetic languaging is a re-search tool as

such. It is primarily a tool for re-discovery and being taken by surprise. Therefore, it is a basic medium to train the open-minded attitude of any expressive therapist.

Communication and Communion

Earlier we discussed the therapeutic process of individuation, noting that visual art and writing tend to be more private activities and, therefore, more conducive to individuation. The exception would of course be a purposeful attempt to draw and write as a group in a shared activity—for example, creating a large, painted mural or a collective or "chain" poem. Even in this type of exercise, however, it is much easier to define a separate space of one's own than in song or dance.

Those modalities and art disciplines most conducive to enhancing communication—or more importantly, *communion*, which implies a true union of people above and beyond the exchange of information—not surprisingly, are those which most easily engage people in a shared space and in shared action. Sound, rhythm and the vibrations generated by movement in music and dance are automatically shared by people in a shared space; in fact, the shared experience is unavoidable. Let us assume that we are performing a musical improvisation together. We cannot avoid hearing or taking into consideration the musical expressions we each bring into the space. We might feel compelled to ask, "How can we be with each other?" "When you are finished, will I still be 'in it'"? The bigger the group, the more interactions are influenced. Moreover, when people dance—especially within a musical environment—they come into relationship with one another and quickly discover that they have choices in trying out various coalitions with the other members of the group (e.g., moving into pairs and small groups).

The rituals and enactments possible in theater provide even more complex forums within which people can interact and test behaviors. Within the medium of theater, confrontation with other characters is inevitable, and the dialogue and play between characters helps images to emerge, develop and mature with a complexity and a thoroughness not found in the other arts. Here, too, myths reveal themselves to us to enrich our understanding of our complex humanity.

Finally, we wish to emphasize that it is not our goal here to present an exact typology for the arts, and none of the traits presented are intended to be absolute. Rather, we want to reiterate the importance of examining the aspects of the arts from a phenomenological point of view. Our need to be clear on this point is prompted by our experience that students often hunger for clear typologies, hoping that they will enable them to lay a firmer grasp upon the work. The hunger is a natural one, but a more mature mastery of intermodal expressive therapy truly requires an open, nonlimiting approach to the arts.

Integration and Separation

We began by insisting upon the oneness of the arts, then proceeded to make distinctions between them via crystallization and intermodal theory. Neither approach negates the other. Rather, both are essential to a full understanding of the interdisciplinary use of the arts in psychotherapy. In fact, unity and difference will always coexist, with integrating and disintegrating tendencies.[17]

The Polish psychiatrist Dabrowsky (1972) explains the fragmentation of consciousness in a framework of "negative" or "positive" disintegration. Any psychic growth is first induced through disintegration. This may be

prompted by a psychic crisis of fragmentation and chaos. Such disintegration proves to be "negative" if it solidifies the fragmentation and ends on a lower level of consciousness. Often it may end in a mental disorder. It is "positive" when it leads to a more differentiated level, when chaotic fragmentation is differentiated and accepted as a multiplicity that does not have to be forced into the old oneness. The best way to ensure "positive" disintegration is by putting both integration of a multitude and differentiation of a unity to work in tandem, by means of a creative act.

Levine (1992) writes that the integration of expressive therapy must be found in the experience of each individual therapist. What we have in common is imagination, which allows us to express suffering and overcome it at the same time. That process is integrating.

Waser supports these arguments when he defines his model of "shaping spaces." In essence, he makes a distinction between the sensorimotor, the pictorial and the verbal shaping space. He explains:

> The communicative unconscious is really a communicative process of shaping and becoming aware. The process is uniquely stimulated and differentiated by intermodal creative expression. The therapist and client participate as partners in a process of mutual transformation. Both as creator and recipient, each is part and parcel of the powerful energy current that informs the creative process (Waser, 1991, p. 3).

We must train the therapist's sensitivity to understand that intermodal creative expression requires the finding of an appropriate art discipline that corresponds to the sensorimotor, pictorial or verbal "shaping space." Thus, the "powerful energy" transforms through mutual creative powers.

Natalie Rogers, daughter of Carl Rogers and founder of the Person-Centered Expressive Therapy Institute in California, has developed and formulated an excellent method that serves the integrational concept about which Waser writes, while also helping us to understand the connectedness of one art form to another. She calls the principle, "the creative connection" (Rogers, 1993). It is not only an inspirational guide for the practice of expressive therapy, but also a fine tool in the training of the therapist's sensitivity to find appropriate art disciplines in the therapeutic process.

All the interdisciplinary positions have several concerns in common. One of them is the care for a thorough understanding of imagination and of all the art disciplines. Another common thread is the educational and psychotherapeutic interest that seems to be key in this research.

As we approach these concerns from different angles, we arrive at similar conclusions. Even when some point out that it may be important to choose a specific art discipline—such as art, dance, music, poetry or theater—researchers emphasize the necessity to train a sensitivity to more than one art through intermodal training.

On the surface, it may appear that making choices in following a particular art discipline is a bit like choosing a school of psychotherapy. "Eclectic" psychotherapists often fall victim to the idea that they may take a little bit from many schools until they are satisfied with a suitable mix. In fact, the process of finding and defining a therapeutic style necessitates a focusing of attention, a disciplined ability to differentiate, and an entering into depth. Through the creative process, different approaches which attract the eclectic therapist may be synthesized into a unified and highly individualized paradigm. The clinical judgments and choices the practitioner makes, then, depend upon the focus of this paradigm.

Likewise, to define an expressive therapist as someone who picks up a few skills and techniques in the use of visual art, music, dance, theater and poetry, is to overlook the most important part of training. Expressive therapists require a deep artistic and psychotherapeutic conviction, as well as a solid commitment to the in-depth study of imagination and intermodal theory in the practice of the arts. Moreover, this commitment is one which would benefit all clinicians who use the arts in psychotherapy. Indeed, without intermodal skills, we may lose the tradition of multiplicity in the arts and become blind to the possibilities of the people with whom we work, and unable to imagine artistic ways in which we may reach them.

Notes on Part One

[1]To clarify, examples of artistic *disciplines* include music, dance, literature, poetry, theater and the visual arts. On the other hand, examples of *modalities*, or what we will refer to as modalities of imagination, include sound, silence and rhythm; posture and movement; words; action; and visual images.

[2]Memory does not operate in humans as it does in computers—that is, with the brain acting as a storehouse of data and information whose ability to retrieve depends upon the build and precision of the instrument. Bolles is one modern researcher who has found memory to be "an act of the imagination" (1988, p. xi).

[3]Certainly the arts can serve human endeavors related to worship, politics and psychotherapy. However, it's interesting to examine how artists characteristically move in opposition to the *status quo*. For example, artists cry loudly for freedom, on behalf of human souls perhaps, when social powers call for restraint and may even try to promote their cause by manipulating artistic media.

[4]As Moore so aptly put it, "It is impossible to define precisely what the soul is"; however, the term needs to be addressed. In Moore's words, "Definition is an intellectual enterprise...the soul prefers to

imagine... [It] has to do with genuineness and depth... [It is] tied to life in all its particulars...revealed in attachment, love and community..." (p. xi, 1992).

⁵The continuity principle (Knill, 1986) originated as a principle of physics and states that the truth can only be reflected within the continuity of an experience and not in its "likeness" to a particular model. Other examples of continuities in therapy and healing include experiences of *change* or *transformation*, of *interaction* (e.g., between body/mind/ soul, people and nature, inner-outer correspondences, sensorimotor intelligence), and of *ritual*.

⁶Roscher's institute is the "Institut für Integrative Musikpädagogik und Polyästhetische Erziehung," part of the Hochschule für Musik und Bildende Kunst "Mozarteum," located in Salzburg, Austria.

⁷The term *poesis* is the Latin version of the Greek word *poiesis*, from *poieiu*, "to make." Poesis embraces thus the making, tracing ultimately back to the original place of in-the-making. It refers to the use of imaginative poetic language, whether in verse or prose, having beauty of thought. It encompasses the inherent power of the spoken and written word to bring order and logic into psychotherapy.

⁸The language of the imagination, according to Hillman, is metaphorical rather than literal; "it persuades through rhetoric rather than proving through logic," preferring to be evocative and visionary rather than explanatory (1977, p. 198).

⁹Gendlin's "felt sense" refers to a phenomenon which accompanies his focusing method. It is characterized by a "quite right" imagination or image and usually precedes a shift in awareness and a sharpened understanding of a psychotherapeutic process (1981).

¹⁰Display of patients' and clients' artwork has been a subject of some controversy. It is our opinion that the work is highly personal and deserves the same treatment one might offer any sacred object. Therefore, the decision to display it in any way needs to take into account the wishes of the author/artist—as well as the integrity of the image itself, which has a life of its own—and must take place with the utmost respect and honor.

¹¹Although we have been left with no preserved examples of Ancient Greek music—Üñïïöéá, or *Harmonia*—it is thought by scholars that

this ancient art form existed not merely as sound, but that it represented a performance art which was defined as some composite of music and movement, perhaps with visual aspects as well (Nienhaus [Barba], 1981). The term literally means, "a fitting together" (Anderson, 1966, p. 14).

[12]Synesthesia is but one aspect of intersensory perception and sensory integration in humans. Moreover, it is not merely a psychological phenomenon. Modern researchers have found neurological and physiological correlates to these phenomena (Walk & Pick, 1981; Marks, 1978; Stein & Meredith, 1993; and Cytowic, 1993).

[13]Notice that in theater and opera (intrinsically synesthetic forms of expression) the various senses hold equal weight.

[14]Presentation, feedback and reflection are functions which come into play during the phase of closure in therapy; these functions will be addressed in some detail when we discuss aesthetic responsibility in Part Three.

[15]The authors prefer to frame the material of artistic expression as *material of the soul*, so as not to depend on a psychological theory foreign to art itself. However, many others who employ arts as therapeutic tools have found other ways of framing their own work and art equally useful.

[16]The original Greek word is defined as "purgation, especially of the bowels" (Webster, 1983).

[17]Those who adopt an "all one" or "all separate" principle hold to an unsound philosophy that can even indicate a psychic pathology. Levine (1990) in his inquiry compares philosophical and psychological sources with respect to this phenomenon.

PART TWO

Literal, Imaginal and Effective Realities

*The image
doesn't represent
imagination—*

*but it takes
imagination
to get to know
who the image is.*

Before proceeding with a discussion of the therapeutic value of the arts, and particularly in guarding the therapeutic process from becoming destructive, we need to discuss distinctions between psychic realities.

Literal, Imaginal and Effective Realities and the Arts

Even though epistemologists differ substantially in the ways they define reality, they all accept that distinctions exist between dreams, daydreams and imagination and

something we might call the "daily" or "actual" world. The very naming of "imagination" creates a distinction that clearly sets imaginal phenomena apart from the actual world.

Objectivity can only exist in the context of a cognitive framework defined linguistically by the participants of the reality considered. In other words, a reality can only be objectified within the conversation of its participants. This fundamental argument reflected in Heidegger's concept of being-in-the-world questions the accuracy of our fantasy of separation between subject and object.

Flores adds that language and cognition are rooted in our social and cultural participation, a notion elaborated also by Gadamer and Maturana (Flores, 1986, p. 61.). Maturana coined the term, "structural linguistic coupling," arguing from a biological as well as a linguistic perspective,

We humans, as humans, exist in the network of structural couplings that we continually weave through the permanent linguistic trophallaxis of our behavior. Language was never invented by anyone only to take in an outside world. Therefore, it cannot be used as a tool to reveal that world. Rather, it is by languaging that the act of knowing, in the behavioral coordination which is language, brings forth a world. We work out our lives in a mutual linguistic coupling, not because language permits us to reveal ourselves, but because we are constituted in language in a continuous becoming that we bring forth with others (Maturana, 1987, p. 234).

We may recognize our actual world as "reality"; however, in the physicist Heisenberg's words, "what we

essentially see and call nature is not nature, but nature exposed to our questioning" (1962).

In the imaginal realm, images want to speak for themselves, and this can conflict with people's natural tendency to operate in a literal mode. When we explore material through artistic disciplines that extend beyond a narrow, specialized jargon, images can come forth in the poesis of their own imagery and speak poetically for themselves. Flores puts this in the context of Gadamer's approach to the inevitability of the hermeneutic circle, saying, "What we understand is based on what we already know, and what we know comes from being able to understand" (Flores, 1987, p. 30). Only imagination and poesis can break that cycle; or, rather, *shape* it so that it can spiral in and out to enable deeper understanding. Such an attempt at breaking the cycle needs, however, to be in resonance with the emergent, as Mastnak notes (1990, p. 119).

Things "speak to us" or emerge from within distinct realms. As we have stated, the distinctions we make (e.g., dream, imagination, and the literal realm) appear in all the epistemological frameworks. Generally, a confusion about the commonly understood distinctions can threaten an individual's sense of security or safety, and may even be considered pathological. How real a thing can be within the various realms is an epistemological question and will always be subject to dispute. For our purposes, let us consider each of these realms to be "realities," and their distinctions from each other a matter of the historic linguistic discourse we are in. Of course, the distinctions do not make one reality more real than another. Moreover, the emerging world will always be partly hidden and concealed.

We will call this opening in which we exist in the world our *effective reality*. It is created by anything that we are in a meeting with, anything that is acting upon us

or upon which we are acting. Material that emerges from dreams, imagination, fantasies or works of art, then, make up what we call *imaginal reality*. Material that emerges from the so-called actual world, usually referred to as "reality," we will refer to as our *literal reality*.

An *effective reality* may be explained also as the experience of engaging in an "I-Thou" relationship, which does not assume objectivity and is distinct from a distancing "I-It" relationship (Buber, 1983, p. 13). In an *effective reality*, soul is affected and manifests itself physically and psychologically in a *real* fashion. With the term, we follow closely Gadamer's definition of *effective history* in his hermeneutics:

> *A proper hermeneutics would have to demonstrate the effectivity of history within understanding itself. I shall refer to this as "effective history." Understanding is essentially an effective historical relation* (Gadamer, 1975, p. 267).

Similarly, any understanding of the world must build upon the hermeneutics of realities as we have defined them. A proper hermeneutics of reality will have to disclose the *effectivity* of a reality as a foundation for its own understanding. Effective reality, therefore, exists within both the imaginal and the literal realms.

Effective Reality in a Dream Interpretation

To aid in the understanding of distinctions between realities, let us examine a dream and its interpretation.

In the dream we will examine, one of the authors has set fire to Logan airport in Boston and becomes filled with a feeling of exhilaration. Upon going home, the feeling of the dreamer turns to joy.

In the dream, Logan airport is *real*; it truly exists in Boston, and not in Toronto. It is *really* an airport, and not a railway station. And the fire is real; it is *really* fire and not water. These *real* things emerge from an imaginal reality to build the *effective reality* of the dreamer. As each dream entity discloses itself—"speaks" for itself—it affects the dreamer. Moreover, *the essential message in the dream can only be gained through the continual disclosure of its effective reality.*

When we interpret a dream, we need to explore the dream's *essential* message. The interpretation in this case did not imply that the dreamer would or should *literally* set fire to Logan airport, nor did it imply that the dreamer in his literal reality had pyromania or a destructive personality, or that the airport had literally burned. Rather, a dialogue with the image of the fire revealed that mobility was still available.[1] Outward restrictions did not restrain the soul's movement, and a sense of joy accompanied the way home to an inner depth. This became an important effective reality in the life of the dreamer, especially considering in this particular instance that the dreamer was anticipating literally undergoing knee surgery in a few days.

Without a doubt, distinctions between realities are important in daily life. When the distinctions are confused, the conversation we are in with each other and with the world breaks down. This becomes most apparent when the socially understood "ordinary" is disturbed.

Within the context of a religious community, God may "really" speak through a vision of one of its members. The vision then becomes part of the community's myth, and is declared as a literal, true message that is shared and distinct in the conversation they are in. In contrast, a lonely person who has lost a supportive community may have no conversation with distinctions that can be

effectively shared; the phenomenon is manifested in a breakdown called "craziness." Hence, what may appear as a prophecy to one person and community may appear as an auditory hallucination to another. Because the "prophet's" community considers his message to be "real," the phenomenon creates for the entire community a *supportive effective reality*. The "patient," in contrast, may find himself shunned by the larger community and/or subjected, ironically, but not surprisingly, to diagnostic procedures such as "reality testing." It is not necessarily the shared opinion about truth and reality that sustains the discourse. However, it is important that the distinctions are accepted.

Returning to our dream, we might wonder about the imaginal realities of Logan's airport police, passengers and crew on the night of the dream fire. Some may have daydreamed on that night—except for the pilots, hopefully—but certainly no one at Logan needed to deal literally with a burning airport. Even though their effective realities differed, each party experienced his or her effective reality as real—as did the dreamer—and each dealt with the same image: Logan airport. The image of a burning airport not only enters into individuals' effective realities; but it also has its own existence in imaginal and literal reality.

Effective reality is created through being in the world. It is in fact the soul of being. It is what makes us *feel*. In our effective realities, the world comes forth in our opening. This is the "worlding of the world," as Heidegger says. What is more, the way we explain effective reality and its origin is story-making, whether in the discourse of science, psychology or religion. Indeed, if we do not want to get lost in speculation, we must return to focus on the effective reality rather than speculate on the genesis of literal or imaginal realities.

For instance, we might focus on the genesis of the dream, explaining it as the consequence of unconscious memory, repressed feelings, archetypes or spirit voices. But our inquiry will never attain the richness we will find by staying with our effective reality and asking the dream images to speak for themselves. The phenomenon is simply that **the dream comes**, and we have no direct control over its coming. We arrive at an image's *essential* meaning by asking it, "Who are you? What are you? How are you?" and listening to its language without a biasing concern about its origin.

Listening to an image phenomenologically is only possible when I allow it to engage my effective reality. Moreover, an image of destruction or suffering, as in our dream example of the burning airport, may not necessarily create a *de*structive or unaesthetic effective reality; and an image of a peaceful or joyful nature may not necessarily create a *con*structive one.

The meaning of the image of an axe piercing a tree differs for the architect who wishes to build a wooden house and the rainforest native who sees his home being destroyed for paper mill timber. The burning airport image, likewise, differs for a passenger, painter or firefighter whose job it is to set a defunct airport ablaze for training purposes. An image is not in itself destructive or bad. It is, rather, *effective reality* that determines how it is received.

Realities of Dream, Imagination & the Artistic Process

Effective realities are defined by, and therefore cannot exist without, imaginal and literal realities; and they can be characterized by different states of awareness. Dreams, for example, subdue the literal reality of space

and time and expose the passive and powerless dreamer to imaginal reality. In imagination, there is a playful interaction between the literal and imaginal realms. We can be guided or guide ourselves to a certain extent, but the images can also take us on their own course when we are able to surrender. Some images may even appear by surprise and may disturb our expectations.

Effective reality in the artistic process reaches into imaginal reality. Likewise, the shaping of the artistic process reaches into literal reality. The material formed and transformed is literally real and thingly; and the tools utilized are literal "real equipment." In the outcome, the imaginal acquires form, a thingly reality. Animals probably experience dreams and images, and even paint, but only humans are *artists*; only they lend substance and imagination to material. They do it without turning the material into the literal reality it represents. A painted fire does not *literally* heat the air in an exhibition hall, though in viewing it an observer may experience or imagine warmth.

Homo faber, like the gods, makes space for new effective realities through creative acts. Is there not sufficient reason to hope that such creations will abide by aesthetics and that in therapy the new effective realities will radiate the beauty of well-being? It is the discipline of the arts that has traditionally upheld these qualities.

Usually, the artist—unlike many from the field of psychotherapy—is neither concerned about an image's origin, nor its literal "usefulness." Rather, the concern is that the image takes shape in "beauty." Moreover, artists continually experience that images cannot be forced into existence.

We may add that art activities enhance and ground effective reality by creating fields of distinction between

realities that facilitate a vital link to effective reality. In our example of a painted fire, the activity of painting engages in the reality of putting *literal* oilsticks onto a *literal* paper and creating the *image* of a fire that gives the *effective* excitement of setting something ablaze. As we will elaborate later, when we introduce the technique of "framing," it is crucial never to confuse such distinctions in a clinical setting.

Notes on Part Two

[1]For more details on the art of dialogue, refer to the section on dialogue in Part Four.

PART THREE

The Essence of the Arts in Healing

What is it, then, that an Expressive Therapist is doing
if he doesn't prescribe medication,
doesn't anesthetize, doesn't give injections,
doesn't disinfect,
doesn't cut, doesn't sew, doesn't bandage?

His "medication" is the art material,
his anesthetic is the breathing out and into the belly,
his injections are the laying on of hands,
his disinfecting are the sense-ualities
of getting in touch with what is touched,
his cutting is allowing the pain to be expressed,
his sewing is to serve the emerging,
his bandages are the ritual, the song, the music,
the dance, the storytelling, the enactment,
the image-ing.

Yes,
the tools might be different,
yet it is always the wound itself which is healing.

Beauty

One key question lies at the base of all philosophies of art: "What is beauty?" The dialogue generated by the inquiry comprises the field of aesthetics. Each of us possesses a human if not an artist's sense of beauty. But this awareness seems to be taboo in the therapy room—based, perhaps, on a fear that responding to beauty in a client's work puts us in a position of judging the "good-" or "badness" of the work—which might in turn adversely impact the client's self-esteem. But in suppressing our aesthetic sense, we have thrown out the baby with the bathwater, so to speak—wasting one of our most valuable talents for engaging the healing power of the arts and for reaching depth in the psychotherapeutic relationship.

The question is not whether aesthetics has a place in expressive therapy. It most certainly does! The question, rather, is how to make optimal and responsible use of it. This is the question upon which we will focus most of our attention here.

Aesthetics as an academic discipline is relatively young if we consider that the discourse about beauty was already evident in ancient Greece, and yet the discipline was not founded until 1750—by Alexander Gottlieb Baumgarten. His aesthetics was based strictly on the Cartesian paradigm and considered primarily the formal aspects of the object perceived as the source of an aesthetic response. The psychological aesthetics represented by Johann Heinrich Tschokke in 1793 and later by the psychologist Gustav Theodor Fechner postulated that aesthetic effectiveness originates in the life that we as the onlooker project onto the object (Alesch, 1991, p. 29-33).

If we are to explore aesthetics in a way that is truly pertinent to the arts in psychotherapy, a way that nurtures

soul, it is necessary to leap beyond the traditional understanding of formal aesthetics which concerns itself with ideal forms, and beyond the oversimplified statement that "beauty lies in the eyes of the beholder." Instead, we will concentrate on a phenomenon which we call the *aesthetic response*. This phenomenon occurs within persons who engage in the artistic/creative process as artists or performers *and* as witnesses. This phenomenon does not provide for measuring art's beauty against some objective ideal. Rather, the aesthetic response describes characteristic *ways of being in the presence of a creative act or a work of art*—ways that touch soul, evoke imagination, engage emotions and thought. Our purpose here is to focus on the *quality* of response, rather than to try to objectify the kinds of occurrences evoking it. The examination confirms our premise that aesthetics has a significant place in the study and practice of depth psychology.

The Aesthetic Response and Aesthetic Responsibility

An *aesthetic response*, as we will use the term here, refers to a distinct response, with a bodily origin, to an occurrence in the imagination, to an artistic act, or to the perception of an art work. When the response is profound and soul-stirring, we describe it as "moving" or "breath-taking" (*Atem-beraubend*). Our language suggests a sensory effect associated with the image, what Hillman describes as revealing itself in the quick in-breath (or *inspiration*) we might experience when in the presence of beauty (1994)—even though we may sometimes not experience the effect literally.[1]

Gendlin (1981) described the aesthetic response as a "felt sense" in his focusing method—the phenomenon of a "quite right" image emerging. The felt sense precedes

a shift in awareness and a sharpened understanding of a psychotherapeutic process. The language we use to describe the phenomenon (e.g., "moving," "breath-taking," "heart-stopping") demonstrates the imaginal, sensual and surprising aspects of the response. The lucidity associated with the response and the effect on the breath are also pointed out by Bühler in what he called an "Aha" experience.[2] The metaphor applies whether the experience is intensely pleasurable or characterized by pain or disgust. The contrary quality, then, would be *anaesthesia*, so to speak—a dullness, an *inability* to respond.

How, then, might we distinguish between a *lack of response* due to a non-evocative occurrence and an *anesthesia* due to an evocative one? In other words, when a patient fails to respond to a painting, for example, is it because of a dullness in the (non-evocative) painting or the (anesthetized) patient? The awareness of the distinction comes from careful training of ourselves and our clients in opening the senses, recognizing the aesthetic response, and learning to use it as a tool. The distinction is important to the psychotherapist, for the aesthetic response can aid in the attainment of greater depth. Moreover, deep responses that are sensory as well as emotional have the capacity to open a door to the Psyche. This can only be done when we provide sufficient space in our work to activate the senses to the point where trust and confidence foster a sensory responsiveness.

We have a special challenge in confronting the anesthetizing mechanisms in the world of today. Could it be that genuine beauty has become absent from our daily life to such an extent that we have to anesthetize in order to protect ourselves from sensing abusive realities? Perhaps contemporary therapists' concerns about past abuses should be matched with those abuses that take

place in the present; certainly the aesthetic response would then have political implications.

The aesthetic response is a phenomenon existing in the presence of an artistic *product*, while aesthetic responsibility describes a phenomenon concerning the artistic *process*. We will see later that we need to consider both phenomena if we want to be able to make beauty a useful criterion of expressive therapy.

First of all, an aesthetic response, as we have seen, signals the significance of an emerging image, whether it has painful or pleasurable content. This signaling is analogous to the way in which a tightening in the chest signals the heart's endangerment. Dialogue with the image, then, leads to a deepening of its beauty and richness and the revelation of essential meanings. Artistic work or "products" encompass a full range of attractive and repelling images, and all are held in the Eros associated with beauty. The aesthetic response therefore has close ties with the erotic, as we will note in discussing aesthetic responsibility.

Regarding the study of aesthetic responsibility, Rudolph Arnheim commented on the connection between Eros and the arts, stating that no artistic process can exist outside a "loving affection." Such an inclination toward Eros is not necessarily apparent in the object or theme presented; rather, it is more a sense we get from the traces of the artistic process left in the work of art. They are traces of "loving affection" (Arnheim, 1987).

The attention committed toward the theme and object, the intense devotion to the artistic process beyond the limits of space and time, the permeation of artist and object in suffering and joy, are all qualities we attach to the experience of love toward an object. For Platonists, beauty is what is lovable in a strong and vehement sense. Eros drives the philosopher or artist—the same Eros we know in myth (Armstrong, 1987, p. 61).

The erotic experience in the making of art culminates in the *letting go* of the work when it is recognized, illustrating a truly nonpossessive attitude within the erotic engagement. We can observe these qualities also in the processes and works of art among "non-professional" artists, including children and people in therapy. These qualities are not necessarily sufficient criteria for measuring the greatness of a work of art, but they make the work distinct from utilitarian activities—that is, artistic activities for which the end justifies the means, like photos that satisfy a marketing goal, or tests and assessments which satisfy a preconceived mechanistic evaluation. (This is not to say that under such conditions a piece of art could never evolve; even under these circumstances art can sometimes flourish.)

The presence of beauty therefore is not bound to the concreteness or abstractness of the theme or object presented. Beauty radiates through the ways and means in which the emergent—originally conceived in loving affection—approaches us. This is what touches us so deeply in works like Picasso's "Guernica," Kodaly's "Psalmus Hungaricus," Bosch's Hell, Breughel's drunkards, Bach's torture scenes in the Passions, or many times in the painful pictures, movements, sounds, rhythms, acts and words of clients. These are presentations that attract our attention and empathic perplexity without awakening our anxiety or defenses. The power of beauty that allows us to approach the painful, the suffering, the ugly, the repulsive, is archetypal, as is well-depicted in the myth of "Beauty and the Beast."

When we respond to the emergent responsibly in an artistic process, we are exhibiting *aesthetic responsibility*. The specific qualities essential to achieving an aesthetically responsible attitude, which guard the therapeutic process from destructiveness, are discussed in greater detail next.

Aesthetic Responsibility in Practice

Once a therapist is prepared or "purified" and able to be present to the work,[3] he or she is ready to apply theory and language indigenous to studio art—in other words, aesthetic responsibility. This application of aesthetic responsibility becomes a confrontation, in a therapeutic sense, and a vital part of taking an artistic approach to the therapeutic relationship.

Certain qualities characterize responsible aesthetic participation in the artistic/therapeutic process. They include:

♦ strong, committed attention;

♦ a surrender that exceeds the limits of time and space;

♦ a permeation of boundaries between artist and emergent;

♦ a nonpossessive attraction/yearning toward the emergent;

♦ letting go of work when it is recognized; and

♦ the condition that the validity of the process is independent of the beauty or "beastliness" of the emergent.

These principles are illustrated in examples to follow, as we discuss the power of beauty in intervention.

The Power of Beauty in Intervention

*Ordering the disorder
and disordering the order
until it organizes itself*

Aesthetic considerations guide us in facilitating an opening and sensitivity to the effective reality of the arriving. We will be concerned about techniques and methods that increase aesthetic responsibility, unlock creativity, and foster technical skills for an opening to the imaginal. What does such aesthetic intervention look like in practice? Several excerpts follow.

An Example from Acting

The stage allows us to be present with what is "offstage." In drama, a therapist might use the intervention:

> *"The voice and gesture seem incongruent with the character being portrayed. Let's explore the range of the voice in connection with the statement just before Ann enters the room."*

Theater is an art discipline which has deep psychological effects, when the studio work is honed to optimum aesthetic quality. Moreno recognized and made use of this power in his "Theater of Spontaneity," through which he developed and perfected his psychodramatic technique (1959). The power has been recognized and incorporated into acting theory as well, including the work of Konstantin Stanislavsky (1961) in Russia, Jerzy Grotowski (1970) in Poland, and the French filmmaker Jean Rouche (1975).

An example from Dance/Movement

Unlearn, relearn to move.
Go with what moves you.

In dance, we might observe a dialogue as follows:

Therapist: I see your upper torso and arm movements reaching outward and diagonally halfway up, as if they were soaring wings; but I can neither perceive a grounding nor a flying. This is particularly evident in the legwork.

Dancer: I want to be a bird, and I sense that I cannot get off the floor.

Therapist: Try to get a sense of the air. [She guides the client in breathing strongly and making wind noises by mouth. The feet then move more directly downward, calling forth a strong, deliberate effort almost like that of a bird stomping just before springing from a branch.]

Therapist: What is still standing in the way of your becoming airborne? Explore the movement of your neck, upper torso and shoulders.

[Eventually, after a period of similar interchanges, the client opens his larynx and screams like a sea gull, then jumps up and appears convincingly airborne in an improvised dance movement. The emerging dance appears beautiful, cathartic, and emotional.]

The movement brings up what we might expect within a framework of solely body-oriented psychotherapy, the difference being that the breath, body and voice work here

are framed within the discipline of an art becoming increasingly beautiful as the essence emerges. While we might aim in a solely body-oriented psychotherapeutic method for the same goals, aesthetics are not considered in body-oriented interventions.

Examples from Painting

We cannot understand the dream (or image) until we enter it (McNiff, 1993).

In drawing or painting, a therapist might encourage others to find the "right" images by offering interventions like: "Try bigger paper!" "Use more water!" "Look at it carefully before you go in!" "Do it again!" "Watch that negative space!" and "Try to define the space with color only."

Painting has the added advantage of permitting work with material for many sessions without "losing the thread," because the material remains present from one session to the next. One can rework a painting, or start all over again. Also, the manifestations can be viewed side-by-side, as a documentation of transformation in progress. Holding and contemplating a series of images can be much like catching the effective reality of a life's being and witnessing its actualization.

Examples from Writing

*The art of writing
begins with
listening
to what makes me
see*

Writing allows in its link to thinking a re-viewing back- and forwards. Through the messages of the emerging

metaphors and voices, we find meaning for the past and conjure a future. The search for meaning usually happens after surrendering to the presence of inner seeing and listening during the writing process.

In working with poetic language, the aesthetic responsibility concerns writing and reading.

For writing, the therapist might encourage a period of spontaneous free writing without stopping the writing flow.

Then he might suggest going over the freely written text to find aesthetic responses. The responses might then be separated on a piece of paper according to their qualities. The client might further be advised to play with these loose word combinations, adding, changing or leaving out certain words; treating them like pieces of a mosaic, until a poem emerges.

In presenting the text, the author might be encouraged to speak loudly and to articulate, repeat, exaggerate or use gesture or even the whole body in motion to better crystallize the expression.

Spontaneous, free writing methods help the writer to overcome stereotyping. Avoiding the "parental" or "teacher" stance of coercing with clear-cut instructions can be a powerful therapeutic intervention. It facilitates an author's moving with his own intuition, felt sense and imagination. These methods help the author to build a relationship with the creation. As he allows himself to be touched by it, the text itself serves as a therapeutic intervention.

Examples from Music

Music
You are the queen of time
You bring me to the never-ending here and now.

[In this music session, a therapist wants to find out if the intent of a client is to have a regular or a metric beat applied to an emerging rhythm. A technical suggestion for clarification leads to the discovery that a swinging in and out of the beat is intended/desired.]

Therapist: All right, let's work on the extremes, then. Start with the ametric, chaotic sound events, and then after a silence explore a simple beat on one or two notes only.

[An intense studio work ensues. The differentiation of the moods of the two extremes brings up images that point to the difficulty the client has in life to keep his center when things get chaotic on his job. Only after a deeper understanding of the dilemma does the improvisation find its convincing form radiating beauty.]

In a *group* music therapy setting, the following scenario might emerge:

While listening to the tape of a group improvisation, the therapist analyzes with the musicians the structure and form of the piece. Following the analysis, the group arrives at a consensus about how to reinterpret the piece. They play until aesthetic satisfaction is reached. Through improvi-

sational studio practice, many group dynamic issues resolve, as the group strives for a convincing musical form that satisfies criteria of *solo* and *tutti*, development and treatment of motifs and themes, and so forth.

When the aesthetic reflection has priority over the corrective one, it takes the pressure off the therapeutic relationship, a pressure that can result in a guilt-fostering striving towards psychologically formulated moral goals. In a music session, for example, suppose we encounter a student whose triangle playing is drowned out by the rest of the ensemble. It may be tempting in our frustration, out of a concern for the group dynamic, to respond in what may be experienced as a shaming way, by putting the triangle player on the spot, attributing the phenomenon to lack of assertiveness and insisting that the more "dominant" others quiet down. Group dynamic issues can in fact resolve quite successfully when we stay with the music-making process without making the interpersonal issues explicit. The therapist might, for instance, suggest listening to a recording of the session, invite feedback on what people hear, and upon hearing no trace of the triangle suggest repeating the performance until the sound is more aesthetically balanced and appealing.

What happens during this kind of enhancement of effective reality might be referred to as a psychological intervention on aesthetic criteria. It brings the effective reality to the depth of the soul, where Eros and Psyche originate. Enhancing effective reality through Beauty is therefore soulful and manifests itself psychologically and physically.

The Aesthetic Response as an Intervention

We've just examined therapeutic interventions in the shaping *process*, based on aesthetic criteria and having a focus on aesthetic responsibility. In expressive therapy, we can also provide a space for therapeutic intervention when we meet the *products*, the finished work—paintings, stories, poems, songs, dances and presentations of theater and music.

For many therapists, approaching confrontations with the work may feel more secure if the encounter proceeds in a way that allows for the outcome to happen according to a well-defined theory. This approach, however, may miss the proverbial "boat" travelling over troubled waters. In attempting to "fix" realities on this shore, the therapist may lose sight of the expandable effective realities—and this vision must be guarded if we want to reach the other shore. A more promising approach to "meeting the work" in a therapeutic setting has its foundation in the aesthetic tradition based on the aesthetic response.

Even with adequate preparation, the clarity and alertness required of expressive therapists for such intensive work demands tremendous stamina. In an environment of such intimacy, one must be constantly vigilant to countertransference material.

Countertransference Considerations

You make me move forward
But you come unexpectedly from behind—
It's all unclear
until I can see YOU.

What we need to achieve is precisely what we described above as a "purifying" or cleansing attitude—a careful watchfulness, ensuring that we don't contami-

nate the aesthetic response with neurotic needs or countertransference. We will have to examine constantly our motivation to respond and our attraction to the work, with questions such as:

♦ Is it the "Aah" experience of beauty—that experience which feels good and is easy to love—that attracts me? On the other hand, do I have the desire or the stamina to endure painful or ugly material?

♦ Am I more attracted to the satisfaction of having observed something that confirms a psychotheoretical speculation than by beauty? Am I in love with the Sherlock Holmes game of confirming my own hypotheses and being recognized as a successful therapist?

♦ Am I truly surprised about the material encountered, or just surprised about seeing what I thought might come? In other words, am I proudly astonished that I was "right"?

♦ Do I bring a subtle curiosity to the material? Is it a keen, loving affection accompanied by joy, awe and a respectful fear that causes me to respond aesthetically? Or do I seek a familiar game of pretending interest to pull off something sensational? Am I brave to show interest despite my real anxiety?

♦ Am I ready to be confronted with unknown aesthetic cues and nurture them until they attain mastery and comprehension? Or am I influencing the development of a piece of art with my response, in a way that satisfies my formal aesthetic criteria for a portfolio about client art?

♦ Can I be honest about a lack of an aesthetic response, knowing about the importance of that recognition to the client, and still ask for a transfer into another art form to explore its meaning? Or do I simulate an aesthetic response in order to have a "good feeling" or manipulate the session towards closure?

There are many more such questions possible. Each touches the dilemma of countertransference.

Questioning a therapist's motivations is essential to an analysis of countertransference. We must also question the aesthetic motivation that drives us to engage in activities which reveal the painful, ugly, shocking and repulsive. Is it the thrill of sensationalism, the deficiency behind a helping syndrome, or bravery compensating for anxiety that spurs our motivation? Or is it the sensitive discovery kindled by an intense loving affection towards the emergent, a committed attention and permeation surrendering to the container similar to that of an artistic discipline, as articulated earlier? Is the attraction experienced not possessive? Is there enough space for separation, similar to the letting go of an artist towards the work? Do the compassion and devotion to the painful bear the radiance of the aesthetic response—the "Aah" and "Aha" of recognition? We call this questioning of the motivation an *art analogue inquiry*.

The analyst Müller-Braunschweig, in keeping with our preceding discussions, defined the work of psychotherapy as an "analogue" to that of art. Let us make it clear here, however, that the client cannot be compared to the piece of art; rather, it is the *situation of the two*, client and therapist in their encounter, which is analogous to the evolving art (Salber, 1980, p. 19). We have seen that the presence of beauty and love does not necessarily depend on the content of the artistic work. This presence is a

consequence of the *aesthetic responsibility* during the process of opening and an *aesthetic response* in meeting with what emerges. The myth of Beauty and the Beast, mentioned earlier, symbolizes this phenomenon and can be understood in an art analogue inquiry.

During a symposium at Harvard University in 1986,[4] scholars undertook an investigation of the art analogue inquiry. In the symposium, a discussion addressed psychotherapy with victims of torture in the Cambodian war. Should clients be encouraged to tell about their trauma, or should they be helped to forget the experience, in the hopes of being freed from the nightmare? Relying somewhat on knowledge gained from psychotherapeutic experiences with World War II veterans, some warned of the potential of psychotic breaks with the opening up of material. Others warned that severe depression could result from efforts that helped clients to forget the nightmares. Research material was inconclusive in both cases, and to shed more light on the issue, the discussion turned to an examination of countertransference. Most participants agreed that the ethical issue behind the question could not be solved once and for all by choosing one of the proposed methods.

An art analogue inquiry into the ethics of a problem like this will always bring into question acts of intervention that *force* disclosure (out of hidden sensationalistic motives), or those that *cover up* (in an attempt to hold onto a moralistic aesthetics). An art analogue inquiry also questions mechanistic methods that literally repeat the experience of anguish, instead of patiently providing a safe and open container in which the pain may take its form when it needs to and find the passionate space to transform.

The presence of beauty and love in therapy is analogous to its presence in the arts, regardless of the object

or theme indicated. However, it must radiate from the work itself, or the therapeutic relationship, if it is to succeed. As we have noted, this depends upon the aesthetic responsibility during the process of opening and the aesthetic response in meeting what emerges. Attending the painful, ugly, shocking and repulsive can then be tolerated with compassion, as images that exist separately from moral judgment and are essentially beautiful.

An example may help to illustrate how this might work. During the Harvard symposium, a psychiatrist introduced the case of a woman who suffered in a Cambodian concentration camp. She presented her horrifying story in a therapy group only after her therapy was well advanced. Spontaneously, the group responded to her story by enacting a traditional ceremony of their native region. Within that ritual one of the "elders" did a storytelling about a terrifying "black" tale of their homeland. Through the art of storytelling, the traumatic experience of the client was received in the archetypal circle of this ancient myth of these people, which was capable of holding the unbelievably painful stories of their culture. The experience could not correct the original situation or make it better; however, it did provide a safe container for the client's passion and openness, which allowed the pain to take the form it needed and find the radiance of archetypal beauty.

Nurturing a strong commitment to beauty, the expressive therapist is a servant to the emerging imagination. Passion, Eros and transformative aggression will be needed and used in the humble service of the meaning that arrives. Ego has to move out of the way, or else the therapist will not be able to invite surprise. Therapists, like artists, need highly disciplined skills and patience to stay with helplessness, a task made bearable with strong faith. Being an expressive therapist demands a religious posture of staying open to all the soul's light and shadow.

Presentation, Feedback and Reflection

A key aesthetic consideration in therapy is how to present a person's work for feedback and reflection, and how to present the feedback itself. We would like to elaborate on issues surrounding the presentation of art works in ways that promote greater communion among people.

To facilitate the sharing or processing of work, the therapist utilizes traditional rituals of presentation. When asked, "How do you want to present your work?" a client may choose to make an exhibition or a performance of music, dance or theater; recite a poem; or perform a special ritual in meeting the work. As a fully present witness, the therapist becomes part of the effective reality. The distinction will have to be made between imaginal reality, performer, witness and their realities. By clarifying that, we assert the need to protect the effective reality.

To ensure that we protect the effective reality, we must remember: **The artist is not the image, nor is the image a part of the artist.** We can reframe the phenomenon by saying that images come to an artist and, being received, they may have an important meaning for him or her. When the images are *present*ed to others, they become gifts that promote dialogue, exchange and communion.

Levine writes in his essay, "Bearing Gifts to the Feast,"

The presentation also has the structure of a rite of passage. It requires the presenter to separate him- or herself from the group, to enter a liminal state of suffering and vulnerability, and, finally, to be re-incorporated into the community...But if the group cannot re-incorporate them in this changed

condition, the presentation will remain incomplete and ineffectual. Thus the presentation requires the participation of the group if it is to succeed...We can see now that the presentation as a rite of passage is essentially to be understood as an exchange of gifts.... That is, the group becomes alive to its own giftedness through the gift of the presentation and, in gratitude, wishes to complete the circle by returning the gift...What is wonderful is that the exchange of suffering forms a community of healing. When the spirit of the gift touches the group, sorrow is transformed into joy. This is not the "happiness" that comes from avoiding pain, a condition that is shallow, transitory and unreal. Rather, it is the deep abiding and authentic encounter of soul with itself and soul with other. It is communitas, the experience of human kindness (Levine, 1992, pp. 53-56).

This communion is an enhancement, a widening of the effective reality that helps to make distinctions that are not possible if the frightening imaginal is not shared, as may happen in a framework that confuses these premises.

If the presentation is a performance, we need to resort to the framing techniques of the performing arts. This is necessary, because in the performing arts actors may easily be confused with the images they serve. A performer who plays a torturer, for example, is not within our phenomenological premise someone of whom we must beware, else he literally perform a torturous scene. On the contrary, the performing actor merely *serves an image* so that it can emerge. Still, this task may have particular meaning within the effective reality of the actor upon whom it has fallen. In the moment of performance,

it becomes our effective reality, too, and becomes meaningful to all of us. The image dwells in the world independently from all of us and visits us in the presentation. Are we able to confront it without blame, defensive labeling or a need to push it back into the hidden where it will act unnoticed?

Certainly theories exist that speculate about the meaning of these performed roles. These theories again, however, are not *literally* true. They are the theorists' imaginings, and therefore should be kept open to further interpretation. Perhaps there is some truth in an analysis that such roles are "shadows of us" or "repressed feelings trying to find form," but such generalizations fail to meet the scrutiny of soul research. We would expect more imaginative particularity. No research should be restricted to those theoretical options. Rather, if we allow roles to reveal themselves, then when we listen carefully and courageously to their language, they might become many more things, have many more meanings. When we focus foremost on external theories of interpretation, we hamper the true power of actualization in the work of art. This power needs the care for an opening to the totality of the emergent. It may reveal, as a result, the purpose and meaning we most need to hear.

Framing, a way of using the arts to structure sessions and contain therapeutic material, helps us become present to the effective reality in an atmosphere of safety, while not confusing the presenter with the presented. (See also discussion in Part 4.)

Clearly, the modality with which we most associate the presenting of material for the purpose of reflecting and offering feedback—sometimes referred to as "processing"— is verbal conversation. It is the modality with which we are most accustomed to sharing responses and further expanding upon our understanding of material. It is a

popular choice of modality; however, it can have its drawbacks. Most notably, when people engage each other in a nonpoetic language, they can easily fall into strict labeling of material, judging and accusing, and advice-giving.

An alternative approach is to share responses in an artistic, imaginative way. After a group process centering on a single group member, for example, peers may create visual images that reflect their response to the material that has emerged. Or individuals may tell stories describing memories that have been touched or similar experiences they have had. One might even share a simple sound or gesture that embodies a particular feeling evoked. This imaginative approach carries with it the additional benefit of truly validating the experiences and feelings of a person—which is often what he or she needs most—without fostering a temptation on the part of those sharing to "fix the problem" or rush to find a quick and perhaps premature resolution.

Reflection is an important part of every therapeutic experience and assists in bringing a feeling of closure to an encounter. *Intermodal* reflection is a valuable technique that requires training and sensitivity to sensual, perceptual and functional distinctions between sensory modalities as well as to the common ground shared by all the arts.

Eros

You break in my breath like perfume
You season my lungs with your spice
rush through my veins
and storm my pulse
like a young creek from the mountain in spring
oh oh the basin of my soul craves zealously
yearning for the flooding of my banks
succulent sap of my muddy swamp
you come...and
I scream for a boat
while the tidal waves wash on my house
break in my door
and rock my furniture like cradles.

In the following we shall embark on an inquiry about love, taking care not to define it in a rigid way, for that would destroy its ambiguities and multitude of meanings. We know this pursuit of grasping for an understanding of love as an endless quest for words. It seems that the essential things of life, like love, can only be adequately named in poems, stories or stutterings. Love resists precise definition in the fields of philosophy and science, existing in a pool of endless possible entanglements. So, we can accept the stuttering and stammering, helping ourselves with images and stories—using names like Eros, Sexuality, Empathy, Agape, Epithymia, Philia—and pray to goddesses and gods; or else we can stubbornly attempt to have one definition of love, which in turn will restrict and limit imagination.

Choosing the former path, we will near an understanding of *love* as containing every interpretation that it ever had or will have. We will explore specific aspects of love, as we have explored other images and ideas in this work—

imaginatively. We will conjure those words and images which seize particular perspectives, shades, colors and textures of love. Nevertheless, no scholarly writing about love, including this one, will honor it as the arts do. What, after all, can capture the essence of love better than a poem? In short, nothing else will be attempted than to initiate a discourse to recognize and validate this fact humbly and distinctly.

Love and the Rainbow of Feelings

Is love a feeling, a state of mind, an attitude, a substance of soul, or something simply inexplicable and mysterious? Following our desire to avoid strict definition, let us examine a group of seemingly related terms, including *emotion, mood, affect* and *feeling.*

An interesting graphic display, called "The Basic Emotions" appears in a textbook for medical students specializing in psychiatry (1980, p. 69, figure 4.2). The figure resembles a wheel, with a cross for the spokes. On the vertical axis, the top bears the marking "joy," supported by "delight and happiness," and in its upward extension, "ecstasy." This "up" mood is contrasted at the bottom of the page with the marking "sadness." It is reached by passing through the sign "low," reminding us of the low mood. The deepest pit carries the insignia "despair." To the left side, we find "fear" reached through "apprehension" and ending in "panic." To the right, the path passes "irritability" on the way to "anger" and finally reaches, in its extreme, "rage." This schematic drawing is partially replicated below:

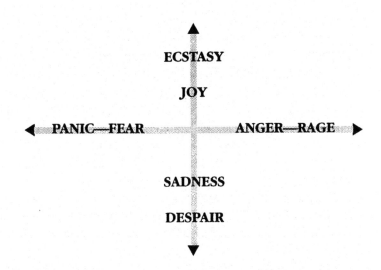

ECSTASY

JOY

◄ PANIC—FEAR ANGER—RAGE ►

SADNESS

DESPAIR

This circle of feelings portrays some of the dynamics we observe in psychotherapy, though the terminology needs more clarification. Who does not know this off-center displacement between anger and fear, fight and flight, anxiety and murderous rage? Who cannot sense a circling when locked states begin to move? Often we need to pass through anger in order to reach tears or laughter. In other instances, we need to slide down to the depths of despair before we can reach the power of anger.

This feeling circle is a beautiful metaphor for what we often experience in psychotherapeutic work. Though we don't recommend the image as a ruling principle or an exclusive model, it is a useful image which might help us to gain a better understanding of emotional terminology.

Most clinical manuals, the revised *Diagnostic and Statistical Manual* (DSM-III-R; Spitzer, Ed., 1987) included, offer confusing uses of terms concerning mood, feeling, emotion and affect. Some are outright contradictory.[5] We have yet to find a single clinical diagnostic manual which mentions the four-letter-word *love*.

Within our clinical seminars at Lesley College,[6] we have sought clarity for our work in expressive therapy. We will attempt to summarize some outcomes here:

Feeling is the sense of life we all have, which we can talk about or meet in our images. We need a safe space to allow feeling to flow into expressed emotions. *I sense a feeling.*

Emotion relates to feelings accessed and put into motion: tears of sadness or joy, chuckles of laughter, whimpers of crying, the trembling or stuttering of fear or rage, panting, screaming and sighing. This material includes all that Gendlin (1981) calls the "felt sense" or what we might recognize as utterances of soul. *I show an emotion.*

Mood is the "climate" within which feelings dwell. High, low, irritating or anxious moods color and determine our emotional *potential. I am in a mood.*

Affect describes *emotional capability.* Clinical language categorizes affects as blunted, flat, restricted and broad.

Pain and **pleasure** indicate somatic sensations. They can evoke a rainbow of feelings and emotions. The sadness that creeps into pleasure is as common as its companion, joy. The anger in hurt can shift to sadness or fear, and even to joy, in reaction to pain.

Love, it seems, is not a distinct term belonging to any of the categories. Certainly, it should not be restricted to the limited realms of feeling, emotion or mood; nor can it be associated with only one or a few qualities of feelings. We can experience love within the entire range of feelings, emotions and moods—including disgust, anger, malice and other qualities that we traditionally characterize as "negative." Love may be viewed as the soul's response to life.

Love and Hate, Life and Death

Love is a lifegiving force that resists attempts made to dissociate it from its physical expression. Sexuality, procreation and the ecstatic and divine aspects of love are intimately tied. Accepting all manifestations of life is not easy. It may be especially difficult to accept those culturally aversive archetypal images in nature—perhaps analogous to accepting Eros on a cruise with Rhino.[7]

Love, with its unconditional, non-judgmental nature, permits a wide range of imagination. The image of an angry, spiritual warrior fighting against war and pollution may find approval; but it might be more difficult to accept as an act of care or love the image of a figure destroying property to get public attention for an injustice. Imagine a lioness killing to protect her young; certainly this image occurs in accordance with love. But moral questions arise if we place the scenario in a human environment of jealousy.

We customarily associate love with forgiveness and redemption, further implying tolerance, multiplicity and an open, spacious inclusiveness. Love favors life in its multiplicity—as opposed to closedness, narrowness and exclusiveness. Love opens toward all the soul's utterances in response to life, and therefore it cannot tolerate censorship.

The freedom requested by those practicing the arts finds support in such reasoning. Only the power of love can create a sky wide enough to hold the entire rainbow of feelings. It helps us to appreciate that rain or a passing thunderstorm may necessarily precede the appearance of a rainbow, or that a storm may serve a valuable purpose in its own right. Moreover, natural occurrences offer us metaphors for experiences of "stormy" rage, or the "wetness" of "melting" sorrow.

When love is absent, we find closing, annihilation and repression, characteristics which restrict or limit life and even seek Death. The glorification of death in some interpretations of Judeo-Christian morality—hidden in the message that life after death promises to bring more fulfillment than sensual life—seems to suggest a restriction of life, especially the more primitive, life-fostering activities of life, like the display of sexuality or aggression.

It is fair to say that most restrictions—which lead to censorship in life and the arts—concern the realm of imagination, the territory of soul, the land where dreams live and the arts dwell. **Paradoxically, opening to images of joy, fear, despair, excitement, rage, confusion and elation do not threaten life; however, the _restriction_ of imagination clearly threatens soul.**

Restricting love and reducing it to a moral code produces fundamentalism, whose rationalization of hatred has been demonstrated repeatedly throughout history. The connection between love and the creative act, which allows space for surprise and wonder, gets lost in such fundamentalism, where instead formalism and literalism reign.

Love as the opening towards unification with the life forces is a true worship of nature, with its light and dark forces, with its chaos and structure, with its attractive and frightening beauty. It would be unfair to reduce the link between love and beauty to the harmless, anaesthetized niceties that people use to cover up the unlimited depth of imagination. For imagination offers so much more than superficial niceties. It has the capacity to vibrate soul violently when we fully experience life.

The Worship of Love with Archetypal Images

Any attempt to make a thing as powerful as love part of a rationalistic concept with a restrictive definition will prove futile. On the other hand, as a matter of soul so closely related to life and death, love has always stirred imagination. This is unmistakably apparent in all the disciplines of the arts across centuries and cultures. Therefore, we can reach a better understanding of love when we attend to the images emanating from myth and works of art.

Many "love" images are archetypal, in the sense that they recur in many cultures across long spans of history. We find astonishing paradox and multiplicity in these images. In baroque paintings we find the not-so-innocent, playful Cupid, without bow and arrow, however, side-by-side with Jove, the god who seems to portray wisdom and timeless age. Both represent love.

It may also be viewed as paradoxical that love often appears in company with Death, as in Irish folk songs, in the story of Romeo and Juliet or in the redeeming sacrifice of the "plumed serpent" or Jesus. Solomon calls love "as strong as death" [Song of Songs, 8:6], and Death approaches a young maiden like a lover in "Manuel's Death Dance," from the early sixteenth century.[9] Goddesses and gods of love seem always to be beautiful, as are Eros and Aphrodite; however, we find a poignant variation even on this pattern when we see them hiding in ugliness, until it magically transforms to beauty *through* love, as in the story of Beauty and the Beast.

Petersen (1987, p. 202) writes about four ceremonial acts of religious origin, which correspond to four forms of love: Epithymia, Philia, Eros and Agape. These same terms appear in ancient Greek philosophical thought, where love was considered a cosmic power of nature that people worshipped in a variety of ways.[10] We will

explore these four "aspects of love" briefly.

Epithymia represents passionate and eager desire, the craving and zeal connected to love. It should not be confused with what Freud defines as libido, or sexual drive. Epithymia acknowledges passion and yearning in all forms of love, including spirituality.

Eros, as we will see later, should not be reduced solely to sexuality. It has as many aspects as there are stories about this god. The common denominator is the corporeality of love concerning the object of desire. In this sense, Eros is sensual.

Philia is the force behind friendship, the power making one person care for another more than just for a service. It is that love which makes lifelong bonds between people as well as between people and things. We find the root of the word in *phil*anthropy, *phil*osophy, *phil*ology, and *phil*ately, to name a few.

Agape has been misunderstood in our culture, reduced to *"caritas,"* love that is spiritually motivated to help people in need, with no expectation of recompense. Yet, *agape* is much more than this. It is connected with religious union or the desire for union. It is celebrated, therefore, in the ritual of communion. Sharing and taking in food together is, after all, an intimate activity. Certainly, *agape* includes *caritas,* but also the ethical conviction behind a revolution, and a fight for justice or peace without expectations of reward.

In Hesiod's *Theogony,* Eros is born out of chaos at the beginning of time, together with Tartaros and Gaia; but to begin to comprehend the meaning of love, even while focusing solely on Eros, we must follow the whole account through. His myths, like those of other gods and goddesses of love, tell more about the soul's world than all the attempts to define love in the disciplines of psychology, philosophy and theology. When we follow

the popular tale about Eros, we meet other famous gods and goddesses who relate strongly to love, each of them entangled in a multitude of love stories with endless variations and contradictions. Should we read and study all of them to become knowledgeable about love? If the alternative would be to consume psychology books instead, our answer might be "yes"; but our trust in the continuity of archetypal imagery within the arts and the oral tradition leads us to believe that any submersion into the great love stories of world literature will evoke similar revelations.

A superb way to make an interpretation of a story is to make another story. This happened in Greece and Rome with the complex figure of Eros, his relationships with his mothers and fathers and his great bond with Psyche. Being born from chaos with the original parents of the world, Gaia and Uranos, he was the personified procreative power, the breath of the creative act. As such, he preceded Aphrodite, who later as his mother became jealous of his interest in Psyche. Aphrodite, with her spectacular affairs filled with the corporeality of love, is in fact much easier to understand than Eros and the metamorphoses he undergoes in all of his stories.[11] Stories about sexuality are customarily clear, straightforward and simple, whereas the drama of love in literature and myth is full of enigma. We observe this phenomenon when comparing the simplistic narratives of pornographic material with those of great erotic literature.

The mystery of Eros is enhanced by the different names by which he is known in rituals and stories. Generations after he was worshipped as the patron of fertility in Thepiai, we find him on the Acropolis under the name of Anteros, the Eros of the answered love, the response within the encounter of love.[12] In another appearance, Eros emerges as a god of marriage, the

protector of physical presence and the bond of love, with the name Hymenaios, Hymenos or just Hymen. We encounter Hymen as a poor boy of exceptional beauty, not rich enough for his beloved, who finally pursues a hero's quest and achieves a happy marriage.[13] Another story tells us that Hymen is the son of the deliciously indulgent couple, Bacchus and Venus—which sounds like a lot of fun and pleasure—while an alternate tale reports that he is the offspring of Apollo and Urania. This might indicate that the bond between lovers depends on beauty and imaginative powers, if the god of marriage has such ancestors.

There is a third personification of the multiplicity of erotic power. Again, we find a young, delightful man, a devotee of Aphrodite. He is named Himeros, the one who grasps the heat of the moment, the sexual voluptuous wanton who embodies the immediate presence of Eros (Grant & Hazel, 1987).

A fourth aspect of Eros concerns the effort to capture his irresistable attraction, and has offered inspiration for a great deal of poetry, such as the following:

> *Home*
> *is where I can be homeless*
> *Home*
> *surrounds unfamiliar territory*
> *with*
> *the familiarity of longing.*

and also this:

> *The longing*
> *for a platform*
> *grows wings*
> *at the edge.*

Pothos, the everlasting yearning and desire for what we cannot obtain, is seen as a magnificent young man, a cult figure in company with Aphrodite.[13] Pothos was called by one of the church fathers *"vis naturalis,"* the vegetable love, the longing power behind the opening of flowers and buds, the longing eroticism behind the eternal principle of organic growth. The only place where such yearning ends is with Death.

Eros, as demonstrated earlier on, exists in company with Epithymia, Agape and Philia. All are major aspects of Love; but Eros seems to be the most powerful figure, as demonstrated by the myths surrounding him. He himself possesses four aspects:

♦ *Pothos* (in German, *Sehnsucht*), yearning for impossible love;

♦ *Anteros*, the response to Eros;

♦ *Hymenaios* or *Hymen*, the physical presence of beauty and erotic bonding; and

♦ *Himeros*, the physical desire and engagement in the immediate presence of Eros, the "heat of the moment."

What may be the consequence of such a differentiation of love for the expressive therapist? We will address this question next.

Rituals of Love in Expressive Therapy

The reader might be tempted to ask at this point, "Why spend so much time talking about love? What's the point?" After all, few contemporary psychology textbooks address the subject at all.

We find the latter fact unfortunate, to say the least. For we recognize that expressive therapists are intimate

companions to art and imagination. We also know the imaginal realm to be an *erotic* realm. And so by definition, expressive therapists work within an erotic realm. To enter this realm in a responsible manner, in partnership with the clients who engage us, we must be aware of the images and stories which reside here. If we are not, we may, for example, confuse eroticism with the most simplistic and literal notion of sexuality and either be frightened away or overstep professional boundaries. Both responses will always prove counter-therapeutic, and sometimes quite detrimental.

Moreover, we view therapy as soul-making. The use of this term brings to mind another way of framing that province within which Eros is ever-present, for soul also resides in the imaginal realm. Unfortunately, in the sadly unpoetic language we are accustomed to using on a daily basis in our contemporary society, we may find it difficult to articulate the wisdom about which Thomas Moore (1992) writes so eloquently. And yet, at some level, isn't it true that we all *know* that soul exists, requires our care, and holds the keys to healing—or bearing—whatever pain and yearning we carry in this world?

The universal passion for love stories illustrates our basic yearning for soul. No other theme is as controversial or shows in its pathos such an intensity of pain and pleasure. When we turn away in disgust, fall sick with yearning or near starvation in the asceticism and ecstasies of spiritual or physical love, the stirring always rises from deep within, engaging the depths of soul. In Hillman's words, this is "Eros in relation with Psyche—the pathological phenomenon of a soul in need of love, and of love in search of psychic understanding" (1977, p. 102). To reduce love in therapy to a didactic method of empathy, a mechanistic view of a sexual drive theory, or a "quasi-electrodynamic" model of organon, is not only a reductionist attitude, but it also lacks imagination. It is

the kind of attitude which makes us miss the boat that leaves the harbor of literalism, sailing out into the wind of longing and the deep sea of the soul, navigating solely on the course of imagination. Could it be that we *want* to miss that boat, because we are anxious that this vessel might not be safe in the storms of passion or might not be well navigated?

So here we might stay, in the harbor of Aphrodite, soothing her envy of Eros in search of Psyche. We could do this within the cult of reductionistic theories. We will then remain on the pier and feed the seagulls of empathy with crumbs of caritas, or go to the beach and surf on the waves of organon.

Our intention is not to ridicule or moralize those activities; they too are aspects of the multiplicity of love. But we do wish to bring attention to the fact that expressive therapy has to do with *soul-making*, and sooner or later we will have to follow Eros and board the ship.

And what is the name of this ship equipped with sails strong enough to hold Pothos, the wind of yearning? The boat, with a crew commanded by Philia, the captain of friendship? The vessel, with a stern crowned by the galleon Epithymia, the cutting edge of passionate, zealous craving, breaking waves as high as mountains? What is the name of this flagship with the anchor Hymenos, the erotic bond able to reach ground in the deepest sea, secured by a strong chain called Himeron, the strong grasp of sexual desire? Who will reveal the name of the ship whose masthead is Anteros, the one always responding to Eros—with eyes like an eagle, able to spot the islands of hope and the icebergs of despair?

The boat has a history as old as humanity. An ancient German song of Advent calls the sail "Love" and the mast "Spirit."[14] Perhaps this "Boat of the Dream" (McKim, 1988) was also Ulysses' boat in James Joyce's psychological soul-search.

The phantasmic and mysterious movie, *"E La Nave Va"* (And the Ship Sails On) by Fellini[15] depicts well this fantasy boat. In the film the ship's passengers are mainly artists. No one ever knows exactly why they are on the ship or where they are going. One particular passenger stands out because of the stench and noise he spreads through the luxurious and otherwise clean quarters. At first, this mysterious traveler is hidden, but he is too big to remain unnoticed for long down in that deep, hot belly where machinists attend the fire that heats the furnaces of the steam engines. The mysterious passenger is a rhinoceros.

At some point, a heavily armored flagship under military rule meets up with the boat. For some political reason, the flagship is after the artists and ends up cutting them off course and bringing the movie to a disastrous end.

It is futile to try to understand the rationale of this ship, never mind Fellini's reason for putting Rhino there. A saner approach is to simply attend to and dialogue with the images. Fellini seems to have invested no small effort to keep the film open-ended, allowing for a multitude of interpretations. He does, however, ensure that the Rhino and captain both survive on a lifeboat. Thus, it may be possible to destroy or negate artifacts, but not their content—the limitless irrationality and bottomless craziness of imagination. The creator of the artifacts, the one who attended the imagination spontaneously, is safe with the monstrous, stinky creature on the boat of the dream— a lifeboat able to contain all this, and apparently capable of being steered clear from a collision with the order of literal "normality" and reductionism.

Contemplating the origins of intermodal expressive therapy, and the continuity it displays by keeping the arts alive, it is striking that the disciplined rituals[16] of painting,

sculpting, acting, dancing, playing and singing music, writing and story-telling, always provide safe *containers*, secure vessels, for meeting the pathos and mystery of soul and psyche. It is not too far-fetched to call the archetypal boat the "Carrier of the Arts," and the skill required to steer it clear from collisions the "Mastery of the Art Disciplines." Within this discipline we exercise an attitude of openness to surprise, patience and humility in awaiting and attending to images that arrive full of insistence.

The guide and guardian angel on the cruise with this boat can only be Eros in his full potential, and not some restricted aspect of him. First of all, only Eros seeks Psyche. And secondly, but no less importantly, the tradition of the arts expresses Eros' celebration of the creative act emerging from chaos. We will recall that Eros was one of the first gods, who emerged from chaos to allow creation to happen. Art is the ritual based on the ability, skill and knowledge to engage the creative act consistently, significantly and persistently in a particular discipline. The discipline as such may also result from a creative act, defining a style or method. Art is motivated by the emotional attraction experienced in meeting the world.

Shaun McNiff shares his own experience as an artist in his essay about Eros and image: "I use the term to describe passionate feelings that we have about the physical world...our bodies, other people, nature" (1988, p. 140). The artist's passionate longing in pursuing an image, melody, act, rhythm, movement or story to its full and radiant beauty and impact has all the qualities of Pothos and Epithymia, including the understanding that the yearning will never find completion until life ends. We find some consolation through the response of witnesses of the art, the dialogue in the physical presence of imagination, the communion with beauty, similar to Himeron

evoking pleasure, pain and the rainbow of feelings. Here we find the aspects of Anteros, Hymenos and Agape. The arts also provide the multiplicity and opportunity to explore the unthinkable—Rhino. This opportunity gives space beyond morals, an archetypal playground of light and shadow, a crack where soul peeks through. No doubt the boat of dreams, the carrier of the arts on a cruise to soul, needs Eros as much as Eros needs soul.

This chapter lends support to the notion that any therapy that wants to address Psyche in all its depth needs to deal with all aspects of love, including those which may be difficult at first to touch, such as Eros and Sexuality. This might be less true in therapies interested in the re-educational and regenerational practices of altering behaviors without touching the base of what makes us essentially human, soul. As therapists engaging the artistic process, we have no other choice but to accept the burden of this commitment to Eros; or we lose the connection with the power of imagination.

Yet, a marvelous blessing remains in this commitment. The arts provide a safe container, a vessel able to maneuver around dangerous cliffs present in the intimacy of the therapeutic space. Tensions and primal conflicts arising from this opening to Eros can be enacted through dance, drama, music, poetry, the visual arts and storytelling. McNiff explains that all forms of emotionally charged art are essentially enactments engaging different senses. This sensual reunification of the artistic process and healing, he adds, engages in its tradition the shamanistic drama (McNiff, 1981, p. 214).

All the art disciplines contain clear frames inherent in the art itself—manifested in a canvas, stage, musical instrument, staying with a story or scene, and so on. These clear limits within the art disciplines provide a great resource for containment and distance. With them, we do not have to comply with restrictive rules foreign to the

process that might endanger trust or positive transference. It is crucial to note this paradox of sensual involvement and distancing within the artistic enactment, which acts contrary to the merger that occurs when things are understood literally, without a sense of the magical space of the arts.

The ancient space provided by the ritual of art disciplines has served for generations to grant imagination body and soul. It spontaneously registers as a *sacred* space, as it has traditionally. Many of us who have worked in groups may confirm the experience that one person initiating that space with sexual imagery opens up the whole group. What may become a "confessional" discussion in an encounter group leads in expressive therapy to the depth of participation in ancient practices of sharing, ranging from improvised fertility dances or rites to mourning songs or ceremonies for lost or unrequited love. Such practices allow for the enactment of unpretentious anger, tears and joy.[17] An honest sharing pours forth and fails to stop at conceptual and moral limits set by language and cognition. The subliminal finds its way, and the organic process of poiesis eventually grasps the image and casts it into a soulful language. The need to *psychologize* Rhino into a nice psycho*logos* rationale gives way to the *philiapsyche* (from the Latin, "Love for Psyche") of enjoying Rhino in company with Philia and Eros."

The Axe that Builds a House:
Art as Disciplined Aggression

Sometimes *pro*-gression
is an
ag-gressive act
followed by
re-gression.

The poetic phrase, "the axe that builds a house" conveys the image of a tool of *con*struction that could double as a weapon, or tool of *des*truction. It suggests an aggressive force, which we require for any constructive or destructive transformation. The image is rooted in the tradition of architecture; but the metaphor conveyed applies to all the art disciplines.

If we deal with the image of the axe in a global context, we find that the purpose of psychotherapy becomes more than a soothing of individuals or a bolstering of their ability to endure abuse. When we accept the complexity of what the image reveals within a wide horizon, we neither deny nor moralize the existence and necessity of aggressive forces. Rather, we allow aggression's essence to reveal itself in its own terms, so that it may emerge from the shadow into the opening that we create for it. Perhaps it will claim our naivete, but not our lives, as long as we stay courageously in the opening. We also need to take care that the fixed light beam we throw into the darkness does not blind us, so that we fail to see the essence hidden in the shadows of twilight.

In dealing with the subject of aggression, then, we posit the following:

♦ The practice of the arts permits an opening to trans-formative aggression, which we will call *destructuring*.

♦ Destructuring is a creative act, literally transforming substance.

♦ We distinguish *destructuring* from *destruction*. De-struction results from blind aggression. Its result could not be a "house," since it does not foster shelter, physical or spiritual nourishment—nor love, nor beauty for the community of humans in the world.

♦ Destructuring cannot exist in isolation from human involvement. It is one of the shadows that needs its essence acknowledged; otherwise, it may act out literally as destruction.

♦ The arts can be a disciplined inquiry exploring destruc-tion as an essential theme. This makes the practice of the arts a twofold blessing: First, as a disciplined practice of transformative aggression in its destructuring; second, as a disciplined inquiry into the theme of aggression, and of destruction.

How does all of this apply to the practice of intermodal expressive therapy? Returning to our discussion of the concept of reality, we will have to make some further distinctions before we can focus on the practicality of destructuring and destruction in expressive therapy.

The "Effective Reality" of Destruction

As we have noticed in defining realities, no images are inherently destructive or bad; rather, the effective reality determines if images are received in a way that evokes hurt, pain or despair, for example. This is a

radical statement in that it suggests that art as a birthplace of images may not necessarily heal, and literal reality's destructive images may not necessarily damage Psyche.

In Thich Nhat Hanh's[18] collection of stories related to war-shaken Vietnam, *The Moon Bamboo*, we find accounts of how witnessing destruction in literal reality does not necessarily promote a destructive effective reality. In the following excerpt, Hong tells of the horrendous news of a pirate's attack on a refugee boat, which ended in a scene of rape and murder.

Listening to Hong, Dao could not hold back her tears. Who knew how many cruelties were committed each day? Her shoulders shook. She could no longer hold back the flood of anguish inside her. She would never be able to understand how people could be so cruel to one another. Perhaps the end of the world was at hand? She cried for a long time, so long that when she stopped, the moon was shining brightly overhead. She saw Hong sitting quietly beneath the moonlight like a bronze statue. Hong said softly, "I wanted to let you cry so you could ease your pain. Go now and wash your face at the spring. It will refresh you. We can chant the sutra before we sleep. It's already very late, and tomorrow I must be off early" (Hanh, 1989, p. 92).

We also know of dreams, paintings or stories connected with destructive effective realities. We might mention the poet Anne Sexton and the painter Vincent Van Gogh, both of whom broke down in their effective realities.

As we pointed out earlier, images as such are "innocent." This certainly does not mean we need to experience literal destruction, nor that Van Gogh should

not have painted. The point is, the foremost concern of expressive therapy—or of any psychotherapy—must be effective reality, and artistic inquiry is a powerful way to bridge and discern realities.

Does it follow that expressive therapy, then, facilitates the healing of effective reality, without applying any censorship on the realities of images? We think so. Following our metaphor, the "axe" must be permitted to act unrestricted in its power, while the effective reality of expressive therapy works on the building of the house.

Effective Reality and Purpose

By declaring the realities of images innocent and shifting the focus from speculations about their genesis to the essence of their effective realities, we further shift value judgment away from the images and onto effective realities. We use the term "destructive" for effective realities that are morbid, and the metaphor "building" for the effective reality of psychotherapy. From here we have not only established a value judgment, but also a purposeful direction that needs to be further elaborated.

Psychotherapy cannot exist without a direction of purpose, nor can it exist without faith. The *Menschenbild* (view of human nature) in its individual and social contexts may be hidden, but it always forms the basis for the direction of purpose. To clarify the underlying *Menschenbild* in our evaluation of effective realities, let us sketch the assumptions woven into its fabric:

♦ Even though being in this world includes dying in it, too, life is purposeful.

♦ The purpose can only be revealed and concealed by what comes forth to us, through the "opening" to the world, provided by our being.

♦ We are endowed with care for this opening. This care includes the individual, social and environmental aspects of the world as it reveals itself in the opening.

♦ An effective reality that restricts this endowment is *destructive* and has individual, social and environmental consequences.

♦ To live this endowment fully means to live in well-being.

♦ Health is not the absence of disturbance; it is *a way of being with disturbances* in a nondestructive effective reality.

♦ An effective reality can be considered *existentially well-grounded* when it is open to all realities, imaginal and literal, and when there is an open flow between all states of awareness. The endowment of care for this opening is not restrictive. What is revealed or concealed through it is always considered purposeful, and even "disturbing" images will be in the custody of this endowment.

♦ *A well-grounded effective reality is the dwelling place of well-being.*

♦ This opening to the totality of realities is a necessary condition for a well-grounded effective reality of being and may be facilitated by the practice of the arts. If expressive therapists want to be guardians who ensure that effective realities do not become destructive, then they need to understand more about this practice of the arts.

The Destructuring of Self and Self-Destruction

The ritual of art cannot be performed without transformative aggression. Each creative act destructures the pre-existing form. This is evident for sculptors who do wood cutting, stone masonry or even the molding of clay. In painting, each brushstroke can be seen as destructuring the image before it. The phenomenon may be less evident in writing or music; but if a composition follows a preconceived notion exactly and with no surprises, the result might be quite mediocre. A surprise always destructures a pre-existing image, as do sudden shifts in dreams. If music is thought of as shaping silence with sound, and dance as shaping space with movement, then each sound also destructures silence and each movement destructures the existing space.

Destructuring happens to the material of literal reality, for example, wood. Such destructuring may become *destructive* to the emerging image when Ego gets in the way of the artist. To reach beauty, the process must open towards the imaginal and, at the same time, towards transformative aggression in service of the emerging image. This service continually needs to move Ego's conceptualizations out of the way, to find the surprising and unexpected that keep us in awe. The transformative aggression of this service destructures, so to speak, Ego's preconceived forms of the "self." Somehow, it is the effective reality of the mythical bird, the Phoenix, a destructuring of self.

How to change is often inconceivable, even unimaginable, to suffering, unless it is destructured through a creative act to revive surprise.

The Artistic Process as an Enhancement of Effective Reality

Meeting
my demon
is like not knowing
who he is
until
I
touch
and
warm
his
surroundings

To protect effective reality from becoming self-destructive, we need to continually follow aesthetic considerations. These considerations take precedence over the content and origin of the emerging image. The existentially well-grounded effective reality must allow responses that are sensory and therefore unquestionably aesthetic and not anesthetic. They should make *sense*, in other words, and not foster the numbness that provides the right conditions for self-destruction. In Heidegger's words, "Beauty is one way in which truth essentially occurs as unconcealedness" (1977, p. 178). To censor emerging images would be to deny truth.

The care provided by expressive therapists concerns itself with opening and being sensitive towards what is emerging and an awareness of the effective reality that is arriving. In their work, expressive therapists need to master techniques and methods that destructure numbness and preconceived forms, that increase sensitivity, unlock non-creative patterns, and foster technical skills for opening to the imaginal. *This therapeutic process is much*

more a matter of aesthetics than of behavioral science. The connection between truth and beauty is established in a careful opening to the imaginal, regardless of an image's origin or content. The emerging imaginal is always purposeful, and when we care with a sense of beauty for the effective reality evoked, we find support and grounding in the artistic process.

Beauty is not bound to the "pleasantness" of the theme or object presented. Beauty radiates through the ways and means that the emergent is allowed to approach us. It moves us when we witness the painting, movements, sounds, rhythms, acts and words of clients in the artistic process, where pain is the subject that attracts our attention and empathic curiosity. This power of the artistic process allows us to approach the painful, the suffering, the ugly, the repulsive and the destructive. Stephen K. Levine writes, "The therapeutic power of art lies in its capacity to render life valuable by showing both its horror and its pity. If we hold fast to this task, we may be blessed with the presence of joy" (1992, p. 114).

The Theme of Destruction

Once a piece of work has emerged from the artistic process, it may well present a theme of destruction. Receiving such a piece—a bit like drawing the Death card in Tarot—can cause considerable stir, because it crosses the bridge between imaginal and literal reality into our awareness. This happens through the shaping of material that renders a "thingly" existence to the image. We have to remember, however, that the effective reality can only destroy when it is not existentially well-grounded. The image itself cannot destroy.

A work of art enters our waking consciousness in its "thingly existence" with a powerful presence, and it is still imaginal, not literal. Someone who shapes psychic

material into an artistic form through a creative act is actualizing the theme. The experience becomes effective reality; there is no need to perform the literal act of the theme. When the theme is "destruction of living matter," even though a scene is actualized in the artistic experience, no life is literally destroyed. This is true for the act of painting, dancing or composing an image of "Phoenix" or "The Rite of Spring," as well as for acting in a "passion play" or in a movie on the Hiroshima bombing, or sculpting a crucifixion.

Still, the question remains: How can we guard that in the meeting of this work, the effective reality remains well-grounded, so that anxiety, guilt, moralistic and political rationalizations or mischievous acting-out do not enter in a destructive manner?

In the process of destructuring, as it happens in the artistic process, we resort to beauty—to our aesthetic sense—as a guarantor of the groundedness of effective reality. In meeting the work that exposes destruction as a theme, faith counts—faith in the purposefulness of images and in the endowment of care towards the essence of opening in our being. The concern, then, is openness to the totality of realities, so they may enter our effective reality and help us to "make sense" through sensory distinctions that we learn. These distinctions will help us to find the language for a dialogue with the emergent that leads us to understanding and meaning.

Again, it is the arts that provide the ritual for such careful activity, as we notice when we study worship phenomenologically. Worship is always grounded in faith and also utilizes artistic disciplines.

Faith
illuminates
the shadows
in between
the seen
and never-to-be-seen.

Faith
imagines
the unbelievable
and
imagination
has faith in it.

A prayer chanted repeatedly has as its roots the tradition of poetry. The totem pole and altar are sacred places for visual arts. A drumbeat and singing are vehicles of surrender for the ceremonial communion. The ceremonial enactments that use dance and sacred play with masks, costumes and props re-enact and actualize a theme and move the experience of it to deeper levels. It is as if the faith and discipline of the arts work hand-in-hand to provide a safe space to be in the presence of existential themes evoking fear, aggression, pain, suffering, exhilaration and joy. Together, they provide:

♦ a **frame** to help the destructuring of realities by opening them towards the essential imaginal, and by actualizing the emergent. (The process of framing is discussed further in Part Four.)

♦ the **actualizing** that is the magic of giving the moment eternity, the transformation of the numinous, the embodiment of feelings and the reversibility of the imaginal act.

♦ the **opening** to the imaginal and yet unimagined.

♦ **repetition**—an unlimited option in the space/time continuum; also, an initial step in dialoguing with and forming healing relationships with images.

♦ the **witnessing** of art work as viable presentations and gifts; moreover, as catharsis and communion.

A phenomenological intervention in expressive therapy must always consider aesthetic traditions. In the process of finding cognition, we will then tend towards the particular through a poetic dialogue and stay away from generalizations or reductions. The presentation of the artistic work will be a major concern and will have to precede any reflective discourse. To stay with an aesthetic tradition will also help us in accepting the imaginal realities presented as they are.

The imaginal reality takes on a permanence after emerging through an artistic process. This is not only true for imaginal "celebrities" like Moby Dick, Mona Lisa, "Silent Night," Hamlet, or the Nutcracker Ballet. The same is true for works that never enter the public domain—the bleeding rabbit painted by a child, the brutal dragon in a client's story, or the lullaby improvised by a group. Each image came and will come again to be recognized. The fact that they do not become public does not make them less accessible for dialogue and further artistic exploration.

The idea that we can change realities once and for all in psychotherapy is therefore an illusion. Images do recur, and that includes images with destructive themes. Certainly, we are aware that the blockage or suppression of imaginal destruction does not work. We need to acknowledge that the introduction of the theatrical destruction of "evil" in a dramatic performance has no perma-

nent effect, either. What will improve are the distinctions we will be able to make, and with this improvement our effective reality may change. As we have seen, these distinctions are facilitated in the artistic process, because of the magic that allows realities to meet each other. This meeting allows aggression to be transformative without denying the existence of destruction.

The arts are a disciplined inquiry that allows destruction to be explored as an essential theme. At the same time, they provide a disciplined practice of transformative aggression that destructures preconceived concepts which lock the option for change. This makes the practice of the arts a twofold blessing and brings them under the wings of Phoenix.

Notes on Part Three

[1]Not surprisingly, the origin of the Greek word *aisthesis* relates to sensation (Webster, 1983).

[2]Karl Bühler of Würzburg, Germany (1881-1943) introduced the term "Aha" experience to describe suddenly arising insights which do not follow a conscious sequence of reasoning, but exist instead on the plane of imagination (Copei, 1970).

[3]A more detailed discussion of preparation and purification is included in Part Four when we discuss presence and the therapeutic relationship.

[4]World Institute of Phenomenological Research and Training, Sixth International Conference at Harvard University, Cambridge, Massachusetts, 1986.

[5]The DSM-III-R, for example, defines *anger* and *sadness* as "affect" on page 391, while on page 401 *anger* is defined as a "mood." The words *emotion* and *feeling* are never defined in the text (1987).

[6]The specific courses referred to include "Diagnostic Techniques of Expressive Therapy," "Psychopathology" and "Principles and Practices of Psychotherapy," taught through Lesley College in Cambridge, Massachusetts (1977-1992).

[7]See "And the Ship Sails On," an RCA-Columbia film, directed by Frederico Fellini, which recounts James Joyce's tale of a fantasy ship, and which is addressed here.

[8]Niklaus Manuel (1484-1530) painted the mural *"Der Berner Totentanz,"* now in Bern, Switzerland. The mural was painted in the tradition of the so-called "death dance," showing the Grim Reaper approaching representational figures of all ages, genders and occupations for the final move (Zinsli, 1979, Figure XVIII). The death dance has its equivalent in the "Great World Play," a theatrical representation of the same theme.

[9]Plato and Hesiod focused on Eros. For Aristotle, however, Philia was the central term for personal love, built on equality and reciprocity—a virtue which valued the welfare of the other (Lorenz, 1987).

[10]Hillman summarizes Aphrodite's activities thus: "We find her love to be a complicated group of myths, now enmeshed with Ares, now with the heights of Uranos, the waves of Poseidon, the concrete artifacts of Hephaistos..." (Hillman, 1977, p. 184).

[11]The underlying story of Anteros tells of two boys, Timagoras and Meles. Timagoras loved Meles, but Meles made fun of him and suggested that he throw himself from the Acropolis to prove his love. And that is exactly what he did. Meles, full of pain and guilt about this, jumped to his own death (Grant & Hazel, 1987).

[12]Hymen is kidnapped by pirates, together with some young women of Athens. It happens that his beloved is among the group. He is able to kill the robbers single-handedly and returns as a hero (Grant & Hazel, 1987).

[13]Pothos was sculpted by Shopas in 295-350 B.C. He is portrayed as a young, ripened man. Gregory Narzianus was the church father who named him *"Vis naturalis"* (Hillman, 1975, pp. 53-54).

[14]The song, *"Es kommt ein Schiff geladen,"* was written by Johannes Tauler (1308-1361). The ancient melody hails from Köln, Germany, 1608.

[15]The movie, directed by Frederico Fellini, was produced by Radio Televisione in Italy and Gammont in France. A home video under the English title comes from RCA-Columbia, 1984.

[16]Rituals are understood here as repetitive practices or actions that serve to link the individual to a larger morphological structure than that of his own physical body.

[17]McNiff reports one case of contagion of Eros: "In one group, a woman was doing explicit and provocative erotic drawings and her work seemed to liberate the group...It was as though she gave them permission to explore a taboo subject. As a result of the entire group's involvement in the creation of sexual images, the impact was deepened considerably. It felt as though we were participating in an ancient and prolonged fertility ceremony" (1988, p. 145).

[18]Thich Nhat Hanh—a poet, Zen master and Nobel Peace Prize nominee—founded the School of Youth for Social Service in Vietnam during the war and served as Chair of the Vietnamese Buddhist Peace Delegation for the Paris Accords.

PART FOUR

Special Considerations in the Practice of Intermodal Expressive Therapy

Needs cannot be met
until I meet them.

Feelings cannot be felt
until I express them.

Thoughts cannot be understood
until I communicate them

Trans-forming my needs, feelings and thoughts
into e-motion
creates the bridge
from me to you.

Relationship as Art

Perhaps the single most important determinant of success in expressive therapy—or in the entire field of psychotherapy, for that matter—is the therapeutic relationship. It forms the foundation for therapeutic work

and influences the impact of whatever techniques or methods may be used. Our bias, not surprisingly, is to treat the establishment and deepening of the therapeutic relationship itself as an art, in which two parties (we'll call them client and therapist) engage the imagination, functioning as the "phenomenon of the third,"[1] in a dance of exploration, discovery, creativity and transformation. Each session, each encounter, each moment of the experience becomes an artistic process, which requires an artistic approach. We will discuss the particulars of this artistic approach after first addressing the importance of bringing a therapeutic presence to the work.

Presence

The therapeutic relationship is facilitated primarily through the *presence* brought to the relationship by the therapist. A therapeutic presence is characterized first of all by a clarity and awareness of one's own psychic state. The way that an expressive therapist prepares for a session requires some form of purifying ritual, in much the same way as religious traditions require them, and the choice of ritual may vary according to personal preference. One might partake in a few moments of meditation or prayer, engage the body in a breathing or movement exercise, or use a simple form of imagery such as leaving one's "bags" at the threshold of the therapy room. It is only through some form of purifying ritual, however simple, that a therapist can be fully present to the work at hand—both prior to a session and at critical moments during sessions.

This brings us to consider the difference between working with the arts in psychotherapy and working with the arts in an educational, studio setting. Both psychotherapy and education are rituals which make use of aesthetic criteria. However, they differ in the contractual

relationship of the two engaged—therapist and client versus teacher and student. Each ritual contracted allows for and requires particular commitments, skills and competencies. In an educational ritual, the requirements derive from the educational goals dictated by a governing body and/or from the needs of an individual who seeks to develop or improve upon a specific skill or area of knowledge. In contrast, most schools of psychotherapy require that the ritual of therapy incorporate qualities of commitment, skill and competence not unlike those demanded of priests and priestesses in many religious traditions.

As an example, in the ritual of therapy the therapist needs to be able to receive a client's "declaration of suffering," or call for help, as occurs in the native American tradition and in the *"Kyrie"* of the Catholic mass. Strikingly, many themes of the Roman Catholic Mass (as well as themes in non-European healing ceremonies) correspond to specific occurrences in the therapeutic encounter, as follows:

♦ In the *sacrament of Penance;* that is, the tradition of confession, we find the "telling of a secret burden." The telling is a critical element in almost all healing traditions and therapeutic approaches.

♦ The *Kyrie*, as we mentioned, allows for a declaration of suffering or call for help. In psychotherapy, it refers to a client's motivation.

♦ The *Gloria*, referring to deference and acknowledgement, corresponds to psychotherapy's acknowledgement of the therapeutic relationship as an encounter between human beings who are images of God.

♦ The *Credo*, or expression of faith, corresponds to the shared faith that therapist and client hold in the effectiveness of the applied therapy.

♦ The *Sacrificial Offering* of the mass is reduced to mere payment for services in therapy. However, in a broader sense it suggests the importance of giving up something significant. Artistic activity offers many possiblities for expressing this sacrifice symbolically.

♦ *Transubstantiation* through the Eucharist suggests the arrival of the "third," allowing for transformation or change. In therapy, there is a qualitative leap facilitated in the encounter with the third.

In the *Benediction* we find the final blessing of the Mass. The language *Ite, missa est* (The mass is ended, go in peace) in its original form suggests that one go *with a task*—for example, "Go forth and sin no more." This direct instruction parallels the importance of providing a client with a clear plan upon departing the therapy. Perhaps he will receive the "homework" to read a piece of his poetry as a daily meditation, for example. In psychotherapy, the "final blessing" might also include the giving of something clear to the patient or client; something that makes sense as a result of the encounter; something that may accompany and/or guide the client on his or her path—a transitional object, of sorts.

In addition, as we have noted, therapists need in the ritual of therapy to abide by the rule of their own purification, a practice that we also find in the shamanistic tradition. This practice involves working through personal issues under constant supervision. This serves to guarantee the clarity of a psychotherapeutic relationship and the ethics ruling this professional ritual.

Medard Boss, who founded "Daseinsanalysis," a style of phenomenological psychotherapy, observes about such preparation, "[The therapist] is, rather, ahead of the patient in his existential unfolding...Such anticipating caretaking and being ahead necessitates the analyst's prior 'analytic purification'..." (1963, p. 73). As a consequence, the therapist brings an existential *presence* to the therapeutic relationship, and this very presence is itself a confrontation with the client. Students who in their training find themselves pleading excessively for techniques and tools need to learn the lesson, *"You* [the therapist] are the tool!"* Therapy happens to a great extent through the *presence* one brings into the therapy room.

Colleges of fine arts rarely if ever demand such requirements of their masters students. So even though therapeutic interventions based on aesthetic responsibility closely resemble the ways in which artists confront each other in their studios, the two disciplines differ greatly with respect to the preparation and training of their practitioners.

Once a therapeutic presence has been established, then, how does one fully engage an artistic approach to the therapeutic relationship? We have found that the artistic approach within the therapeutic relationship is characterized by the following criteria:

♦ an ability to work in **mediated, unmediated and transmediated** spaces (defined below).

♦ a sensitivity to the **aesthetics** of the therapeutic relationship, including the ability to respond aesthetically and a sense of aesthetic responsibility.

♦ an alertness to the **structure and "framing"** of the session, in order to ensure a safe space for creativity and healing.

♦ a "**play**ful" artistic attitude.

♦ a special attentiveness to the artistic/creative **process**, in contrast with the popular emphasis on *processing* in other forms of therapy.

♦ an attitude of **working *with* the material** of the session, versus working *against* pathologies or problems.

♦ an appreciation for and facility with **"communion" and intermodal techniques**.

Mediated, Unmediated and Transmediated Realms

Our capacity to conceive of an "I" is unthinkable without implying "you." From an ontological point of view, the human being is therefore always in a state of encounter, meeting or relationship, through language and thought, as we have demonstrated with Maturana's concept of structural linguistic coupling (1987). States of awareness may be explained by the degree of presence one brings in facing the world, as Gebser (1986) suggested.[2]

Buber (1983) makes distinctions in awareness between the dynamics of the "I-It" and "I-Thou" relationships in facing the world. The "I-Thou" offers a more useful way of conceiving of a *therapeutic* relationship. Moreover, the term "meeting" *("Begegnung")* serves us better than the term "relationship" *("Beziehung")* in describing a therapeutic experience. While *relationship* by definition connotes "in reference to," "kinship," "comparison [mathematics]" and "in conformity [architecture]" (Webster, 1987), *meeting* refers to a "coming together from different directions," "coming face-to-face," a state of being "present at

the arrival" of and to an "experiencing" of something [e.g., "The plan will *meet* disaster"].

Meeting connotes a different quality than relationship. It suggests the acceptance of differences (differences in directions, in the face-to-face and with the arriving), which enables an encounter to happen. Relationship, on the other hand, tends to promote comparison and places value on conformity. Similarly, the German *"Beziehung"* relates to a "pulling," while *"Begegnung"* relates to "face-to-face encounter."

Meeting therapeutic needs, we feel, requires a container which makes it safe to accept differences with respect and without avoidance that could turn the relationship casual or superficial. This is true for all meetings: meetings between humans as peers, humans as spirits, humans and imagination, humans and art, and humans and nature. If, for example, music is not listened to in a safe container like a concert hall or a silent, private place, then it can become casual "background" music and is drawn into the subjective literal reality as a mood modifier. This can happen when we drive a car and listen to music from the radio; suddenly, the same traffic that brought on a depressed mood "dances" the beat of the "soukous" that is on and changes the mood to a jollier, more aggressive one.

Traditional containers of the arts include museums, galleries, symposia, theaters, studios, academies and laboratories. These containers *provide* for, but do not *guarantee* a true meeting. A true meeting with the arts happens only when a person takes a deliberate step. Meetings between humans require such a step as well. The container of marriage can easily end in an uncommitted casualness—or in a disastrous forcing of one party into a role foreign to his or her nature. When people *meet*, they maintain their differences and enter into a more dynamic "dance." Of course, we are most interested here in the

chemistry and dynamics of meetings between therapist, client and the arts.

The therapeutic meeting in general can only happen if both parties agree to a contractual bond, as we mentioned earlier, in which one person asks for help and the other agrees to be present and willing to endure the other without pulling back into the "familiar"; that is, without becoming casual or withdrawn and without manipulating the relationship into a fabrication. The enormous difficulty of this task may explain why it has been so ritualized—i.e., given safe, prescribed forms of containment—in all cultures.

The Dynamics of the Space In-Between

The "space in-between" can be differentiated into three different realms. We call them the mediated, the unmediated and the transmediated realms.

◆ In the **mediated** realm we find the time, frequency and space for the meeting. This is where things are given, set up, handed out, presented, administered, received, distributed and taken away. These "things" might include schedules, probes, medications, art materials, advice, or diet plans. The mediated can be analyzed, reproduced, monitored and sometimes reversed. It is a *quantitative* realm.

◆ In the **unmediated** realm we find all the things in-between that spring forth, are expected, become visible, disappear, hide, reappear and linger. They include things like growing or dwindling trust, the generated transference or arising countertransference, the connection or insight that becomes revealed or hidden in confusion, the complexity of a system revealed, and perhaps an anticipated crisis. The unmediated can

be foreseen or expected, analyzed, compared and described, but never reproduced exactly, nor reversed, nor essentially controlled. It only has *qualitative* properties.

♦ The **transmediated** realm contains all events that cannot be precisely foreseen, planned or administered; they are neither do-able nor enforceable and therefore cannot be mediated, forwarded or reproduced. *They arise unbidden from imagination.* The transmediated here has the characteristic of something that arises or emerges of its own intent. This emergent in the situation of the two in the therapeutic relationship we call *the third.*

We call transmediated events in medical science "placebos" or "flashes."[3] Unfortunately, the terms have come to carry some negative connotations, such as the inference of a lack of substantive effect—the familiar pill that lacks potency in a double-blind medical testing model. From our point of view, we see the placebo effect as something invariably positive, a desirable though non-forcible event that arrives as a transmediated gift to the mediate medication, but only with the unmediated trust that governs the doctor-patient relationship.

The Phenomenon of the Third

In the field of psychotherapy, we know the emergents of the transmediated/imaginal realm as "the third." Grob (1989) refers to the phenomenon of the third as a "gift in the space of encounter," and Petersen (1985) highlights the aspect of the gift that only arrives in an attitude that is free of end-gaining and utilitarianism. He says, "The third is pure presence, similar to the presence of the living Christ: Where two or three are gathered in my

name, I am in the midst of them [Matthew: 18, 20]"
(Petersen, 1985, p. 47).

The third cannot be exactly determined, though after
the fact it can be described as an event and compared
with others. Certain boundary conditions leading to the
event can be pointed out and compared, but there are
no precise conditions, nor guarantees, to determine the
nature or form of its arrival. This phenomenon of
uncertainty with respect to emerging events we know in
modern physics as the principle of uncertainty,[4] discov-
ered by Heisenberg in 1947 and the event theorem[5] by
Eddington in 1935 (Gebser, 1989).

The phenomenon may best be illustrated with a
metaphor. Suppose that two artists meet to build a sculp-
ture together from a piece of clay. At first, the sculpting
acts may be guided by pre-existing or spontaneous
imaginations. One artist reaches in and probes, the other
might follow, and every now and then both act together.
More and more, however, the emerging figure (the third)
will take over in guiding the process. It is the arriving or
emerging image that asks to be served. The artists need
to sense it, meet it with respect, and serve humbly in its
presence. Their own presence can help them to engage
their creative powers, skills and imagination to bring the
work to its fullest bloom and essence. When that is
achieved, it is as if the sculpture has become independ-
ent. The artists no longer "own" it, and it becomes part
of the public domain. It becomes a fertile ground for new
images as well, new stories that are not necessarily
identical to the original "creation myth" of the emerged
sculpture. This attitude toward the emergent we call the
artist's attitude.

Within this metaphor, the clay can be compared with
the mediated; it can be controlled and measured with
respect to its various properties (quantity, humidity, firing

temperature, methods of handling, etc.). The growing understanding between the artists meeting each other, their increased trust and ability to handle conflicting situations, can be compared with the unmediated. The figure or image that appears and emerges as the sculpture is the third, the transmediated. It can neither be predetermined nor controlled. Though it may be described, researched and interpreted after the fact, it can never be exactly reproduced.

The third is an important consideration in expressive therapy because of its central role in the human experience of the arts. Artists know that the power of the work depends on the ability to be open and present in a humble, serving attitude toward the arriving image, the emerging melody, the appearing rhythm or sound, the scene or the message. Such a readiness for surprise requires discipline and surrender in a process that asks for technique *("technè")* in its original meaning—skill, method and knowledge.

We can conclude from this art analogue metaphor of a therapeutic relationship that the practice of the arts may help to open to the transmediated. The practice of the arts then becomes a kind of exercise for an ethical attitude that has respect for the third. The following autobiographical story offers an additional illustration of an artistic attitude which respects the third:

> *My father was a church musician and cabinet-maker. Sometimes, especially near Christmas, he would carve wooden figures. I always watched him to see how he did this, and sometimes he interrupted his singing and whistling—which always accompanied his work—to tell me something. One of his comments touched me deeply and is still very clear in my memory.*

I remember that his knife became stuck in a dark knot, where a former branch had been. I expected that he would go to his special machine to cut the knot out and replace it with good wood, as he routinely did with office cabinets. "No," he said, looking at me. "Not here; this is a manifestation of nature, a gift of God. There are no mistakes in nature. This has to become something important within the sculpture. Perhaps it will become a flower." He then went on carving, and I observed how the knot later became a flower on the candleholder he finished.

The artist approaches limitations, disorders, disturbances or conflict not as things to be eliminated, but rather as things which present challenges for transformation. This is very much congruent with the notion that disturbance is a part of life. In fact the discipline of art can be viewed as a discipline of playing with limitations. Thus, many artists choose technically "limited" media over technically superior media and techniques for the pleasure of the artistic challenge and possibilities. For example:

♦ Black and white photography flourishes despite innovations in color processing.

♦ Historic acoustic instruments with limited ranges continue to enjoy use, even after much wider range mechanical and electronic instruments have been developed.

♦ Some theatrical productions still use simple stages despite the availability of complex and sophisticated stage machinery.

Innovation, then, becomes another artistic tool, no better or worse than limitations. The artist's attitude permits the creation of structure through finding beauty in disturbances, limitations and chaos.

The attitude also includes the courage to eliminate hindrances that block the process. Though the father in our autobiographical story may have accepted a knot in a piece of wood, he might never have accepted an unsharpened woodcutting knife. A classical pianist may accept the limitations of his instrument and its inability to duplicate the sound of a flute, but this is not to say that he would not object to a piano with slightly out-of-tune strings. On the other hand, the same pianist playing a honky-tonk rag may be more accepting of the same piano. And though a slightly dry clay may work well for an artist one day, the resulting small cracks arriving in a figure may be unacceptable to the same artist on another day. The arriving third helps us to make decisions about which limits are challenges to be accepted and which are hindrances to be eliminated.

This artistic attitude has evident analogies with the attitude of a therapist towards disorder, limits or disturbances. There is more to be considered than the simple elimination of "inadequacies" or acceptance of "hindrances." Whatever images, joys or sufferings emerge in the therapeutic encounter, each has a story to tell which may include lessons to be learned and even gifts to be bestowed. To allow this to happen, we need stamina and courage to accept and to eliminate in an unconditional surrender to the arriving third. The techniques we use as artists and expressive therapists, then, serve the arrival of the emergent, and do not act as ends in themselves.

Structure and Framing

> *Structures*
> *cannot guarantee safety*
> *but*
> *they can help to contain unsafety.*
> *Structures*
> *are an attempt to control time.*

In order to create a safe space for creativity and healing, the therapist must carefully structure therapy sessions. An overall "frame" or structure for sessions is essential to creating a sense of safety and trust. In practice, this means establishing clear boundaries with respect to space and time; that is, clear beginning and ending points, a private and secure space, and ground rules for both physical and emotional safety.

Within these overall structures, we find needs for structure throughout the therapeutic process. Fortunately, the arts provide helpful and clear traditions for structuring or framing sessions. Some examples of "frames" within the arts include the following:

♦ For the painter, a *canvas* permits containment at a distance;

♦ In dance and theater, the *stage* provides a sacred space that provides a clear distinction from literal reality by its traditional taboo;

♦ *Masks and costumes* allow spirit voices to speak distinctly through the carrier. Wearing a mask of a fool, for example, one might speak or dance a terrible truth without bearing the literal consequences.

♦ *Poems* provide a frame for naming things differently; they can banish or conjure imagery safely with unusual grammar and surprising logic.

♦ *Music* holds unknown images safely immersed in moods that foster ecstatic or unusual states of awareness.

Frames help to *contain* therapeutic material. There are many scenarios in which this function becomes particularly important. For example, if spontaneous action is called for, as in the one-on-one work in a small space where there is no stage, the psychotherapist must make sure that *people use masks or props when in character,* and remove them when out of character.

To cite another example, if no narrative exists to define time (for instance, in an improvised dance or musical piece), it will be important to *agree on an ending time and/or signal that can be viewed as a part of the ritual or performance,* in order to avoid interrupting the sacred space. The theater term "Freeze!" is a useful signal, as it can be easily distinguished from the appeals an individual might make *in character,* using more familiar language like, for example, "Stop!" or "I can't stand this anymore."

It is very important to emphasize to group members that the "freeze" signal should never be used by a member of an audience, and should be used sparingly by an actor—only in instances where he feels unable to continue, for example, because of a perceived threat to his or her physical safety. Many may feel tempted to disregard these rules and exclaim "Freeze!" in order to relieve emotional pain that the drama may evoke. However, let us not forget that the goals of therapy have less to do with the avoidance of pain than with the confrontation of it.

The therapist, of course, remains primarily responsible for the safety of the therapeutic environment, and needs to be vigilant at all times as a keeper of the safety. By remaining outside of the artistic process, the therapist is able to bring a full alertness and presence to all that is happening in the therapeutic encounter, and therefore will usually be first to call a "freeze" to the action.

Moreover, the therapist needs to *remain aware of the intermodal characteristics of the frame*, as follows:

♦ A dancer in dance functions analogously to a brush in painting. The dancer's body is totally submerged in the image. It is impossible to address a dancer during his or her dance in the same way as one might address a painter painting.

♦ In music, time functions like a canvas, a framed space. Restrictions which are trivial in visual art require definition in music. In order to define the frame, then, we need to clarify the duration of time allowed for the performance.

These represent some key premises which comprise the intense training of a phenomenologically-oriented expressive therapist.

What might be called "activities of recognition"; for example, "processing," "reflecting," "analyzing" or "finding insight" should always follow an appropriately "framed" presentation. Only after an atmosphere of trust is established—capable of holding imagery of distress and destruction, if need be—can we find the well-grounded effective reality that allows the distancing necessary for reflection. To uphold the distance between images and their presenters, which was set up during the presentation, it is important to allow the emerging effective realities to find their own language.

Play

Play lives a "let's pretend."
Theories begin as assumptions.
In play, the whole world can become present.
Theories play with the whole world
and sometimes call this being objective.
Yet
the child knows that his let's pretend is a "let's pretend,"
in the reality of play;
while theories proclaim their let's pretend as "reality."
Like confusing the map with the landscape.
The child would not learn to walk on a map.

As we discussed at the beginning of this document, play is intimately intertwined with the arts, and we must not neglect the role it plays within the therapeutic relationship.

Play represents the earliest and most fundamental intermodal performances of one's life. Through play, the child learns to talk, to think and to "master reality." There are specific qualities in creating a play-ground conducive to learning and healing. They include:

◆ freedom from a fixed purpose,
◆ an "as if" or let's pretend attitude,
◆ a here-and-now presence, and
◆ circularity; as play fulfills its purpose in the act of play, and not through end-gaining.

Though we will not embark on an extensive discussion of this topic, we do feel that it is important to remember the importance of a playful attitude in encouraging creativity and the stimulation of imagination in our work.

Process versus Processing

Certainly processing, perhaps better put as reflection, is an important stage in therapy as a means of putting closure to the process, but in too many cases it becomes the primary focus. No sooner does a client divulge a piece of material—a memory, idea or feeling—than the overly-zealous therapist moves in to process and perhaps over-process, often seeking interpretations of the material that can limit, rather than enhance, one's understanding of it.

In viewing therapy as an *artistic* process, we find that *the process itself* (not the process-*ing*) offers by far the most significant therapeutic value. Often healing occurs metaphorically, minimizing the need for any verbal processing at all. This phenomenon holds particularly true for young children—as documented by Landreth (1991)— and also for adults who possess cognitive and speech impairments. Through the very creation of a piece of art, the telling of a story, or the writing of a song, the soul engages us, if we dare, to enter, explore and resolve the material which visits us in its own "home" territory—the imaginative realm.

What of this artistic process? How do we do the work, in practical terms? We simply open the door to images, and then engage them and learn what they have to teach us. There are a number of ways to approach the image—and we take our lead from the way artists approach them. One fundamental method is dialogue.

Dialogue

As I let myself be guided by the emerging story
the story's coming forth
becomes my guidance.
As I let it speak
it speaks back to me.

An important aspect of the artistic process is the art of dialoguing with images. Heidegger offers us a rationale for the use of dialogue when he discusses the connection between the arts, poetry and truth as a major concern in "The Origin of the Work of Art." He writes,

> *Truth as the lighting and concealing of beings, happens in being composed. All art, as the letting happen of the advent of the truth of beings, is as such in essence, poetry...Language ,by naming beings for the first time, first brings beings to word and to appearance. Only this naming nominates beings to their Being from out of their Being. ...The essence of art is poetry. The essence of poetry, in turn, is the founding of truth* (Heidegger, 1977, pp. 184-186).

From this, we can conclude that it is not particularly helpful to talk "about" images as they affect our effective realities. A more adequate approach happens in dialogue when we talk "with" or "from" them, a method described by Shaun McNiff. He calls it "dialoguing," and in his book *Art as Medicine* (1992), he refers to it as part of the "loquent meditations" in expressive therapy.

> *The guiding attitude of this method is the treatment of images as ensouled. We approach them as we would a person, who similarly cannot be explained. A person cannot be labeled "dependency," "depression" or some other abstract notion. The more we know about lions, the more we see the unique and specific qualities of each animal...talking about images has led to the more intimate and imaginative step of talking with them. Talk about pictures is from the perspective of ego, which controls the*

> *contents of the discus-sion. When talking <u>with</u> an*
> *image, I engage it as a new arrival...and I continu-*
> *ously acknowledge and discern <u>its</u> physical*
> *presence. As a participant in the dialogue, it is less*
> *likely to be reduced to abstract generalizations*
> (McNiff, 1992, 99 & 105).

Though we may believe in the need or benefits of imaginal dialogue, knowing how to do it perplexes some people. Engaging in imaginal dialogue, on the one hand, speaks to a natural human ability; however, it can be difficult for those countless numbers of us who have missed out on an early acculturation to the process. Most artists have some instinctive sense of dialogue, though they may not have recognized it as a particular phenomenon, or even have a name for it.

In short, we talk with images in the same way we talk with a patron saint or with a personal God; the way we talk with a deceased friend or relative; the way we talk with the images that emerge in our dreams. And they answer in *their* way: the way a painting tells a painter: "That's enough"; the way a poem tells a poet, "No—use this word instead"; the way our mother cautions us to "Be careful!" when she's not *literally* present; the way a dream image screams, "Notice me!" Images speak to us in the *language of Psyche*. And as we dialogue with them, they personify and deepen (Barba, 1988, 148-149).

It's important to remember that imaginal dialogue is not restricted to talking to paintings but takes many forms. Someone who acts on stage as a bus driver in an over-crowded bus, when he "de-roles," may dialogue with the character of the driver—and/or the crowd, the bus, or the traffic. After a dance improvisation, the dancer of a "bird in a storm" may well engage in dialogue with the bird or the storm, or with Ariel, the spirit of the wind. When a

music improvisation has ended, the musician may dialogue with the music as a piece, or with a part of it. It is possible to dialogue with a figure, a motif or a melody—for example, a melancholy melody which failed to come through strongly in the music. Another example might be a rapidly-driving rhythm or an instrument which didn't provide what one imagined it would. The writer of a poem may dialogue with the images, movements, acts or rhythms of a poem. If we examine the poem introducing the chapter on Eros, we might imagine that one might dialogue with the "perfume," or the movement of "tidal waves," or the act of "breaking my door" or engage in a dialogue with the one who breaks in.

One can also dialogue by acts, movements, vocalizing and playing on musical instruments. That is, instead of *talking,* the above mentioned actors, dancers, musicians and poets may use other art disciplines. For example, the one who acted as the bus driver may after his performance dialogue with the "crowd on the bus" in a rap song, or he might dialogue in dance with the traffic. The dancer and bird might dialogue in music, with a painting, or in a theatrical performance of Ariel conversing with the storm. The musician could dance the dialogue to the taped music improvisation, or write lyrics as a dialogue with the melody. Similarly, the poet could find and dialogue with a melody or rhythm of his poem. Every artistic discipline offers opportunities to meet works of art through their modalities of imagination, their images, acts, movements or rhythms and sounds, and therefore meet with innumerable opportunities to dialogue.

Working with Versus Working Against

I cannot avoid it
nor
can I force it
IT
comes to me
as
I get to it

A common metaphor used by psychotherapists, interestingly, views psychotherapy as "war." Berlin (1991) offers a few examples to support this finding. He notes that Freud used the metaphor numerous times, making such statements as, "The analytic psychotherapist has a threefold *battle to wage*"; "the patient brings out *the armory* of the past"; "the human ego is *defending itself* from a *danger* which *threatens* it" and "*victory* must be won" (p. 361). This "psychotherapy is war" metaphor—present not only in Freud's language, but in most therapies—focuses on *conflict, tactics* and *strategies* for *fighting* and indeed doing away with the pathologies, illnesses—"*enemies.*" In this effort, we incorporate *confrontation* and *strategic intervention*, and we alert ourselves to the various *defenses* at work.

In art, the emphasis is not on working *against* enemies, but rather working *with* material. There is no actual enemy in art, for *all* material, regardless of how ugly or menacing or painful, can be conveyed in an aesthetically beautiful manner. The artist endeavors to immerse himself into the material and to convey it as truthfully as possible. This process involves an extensive "working with" followed by a heightened experience of the material and ideally some form of coming-to-terms with it.

This notion of working *with* material is supported in Thomas Moore's handbook, *Care of the Soul,* in which he advocates honoring symptoms as a "voice of the soul" and taking time to *be with* rather than *rid ourselves* of the unpleasant and often painful symptoms and moods which are a part of life (1992). We might further caution that ignoring and trying to shut out these "demons" often has the rebound effect of sending them underground where they can exert their power beneath our awareness.

We have found that viewing the therapeutic process as "art" rather than "war" enhances the therapeutic relationship and the path towards healing for the people who dare to engage it.

Similarly, the process of change in therapy can be viewed according to a mechanistic model or an organic model. The mechanistic view imagines that there are "parts of the self" that should be "integrated" to enable "wholeness," implying psychological health. This model thus separates the Psyche into parts that one can add to or take away from, as in the mechanical parts of a machine. To expand upon such a metaphor, much psychological language speaks of our brain "storing memories" and "playing tapes"; and of "programming ourselves" to change, thus borrowing metaphors from modern computer science.

The organic view, which is more compatible with the practice of expressive therapy because of its conduciveness to "working *with* material," imagines change by adapting metaphors from nature. This "modern interactional" view in fact has a long tradition. The natural metaphors which inform it describe the ways that nature transforms, like a snake shedding its skin, or a tree growing buds and leaves. We observe how the new grows on the old and that the new is in fact already present before the old has died, only invisible. This means that things have already changed by the time we think to change them; they trans-

form before we can capture them with our minds. Consequently, it isn't the task of the therapist to make things happen or change, but rather to enhance an awareness of the changes taking place.

Communication and Intermodal Techniques

As we have already indicated, when people communicate with each other, we naturally employ a number of modalities. We use visual imagery, as can be observed in statements like, "See; it is easy—like this..." as we draw in the sand or on a napkin or scrap of paper. Depending on our cultural background, we may use movement by "talking with our hands" or otherwise passing on information with our movements and gestures. We use sound by making noises for the purpose of illustration, filling awkward silences or emphasizing emotions. Sometimes we speak in a poetic language, especially when sharing an intimate space. And we "act things out" when we wish to imitate or emphasize an event that we have experienced.

Because our choice of modality influences our ability to communicate effectively, it is helpful to have a wide "repertoire" of expression. Being sensitive to the qualities of particular modalities helps us in our endeavors to communicate.

As therapists, it is also important that we develop a sensitivity to people's literal or imagined barriers to engaging the various modalities. When we bring this sensitivity to a therapeutic relationship, we can begin where a person is most comfortable. We may, for example, begin with conversation, with a walk, with a silent being-together, or with a game of checkers. Once trust is established, further experimentation with art disciplines is possible. In the end, it is not the music, the painting, the dance, the poem or the theater alone which "does the

therapy." It is the relationship and the communication and communion between people that is most essential in life, in therapy, and in education. The arts *facilitate* this meeting.

Intermodal Transfer

When we move from one modality directly into another, using the experience and products of the preceding process, the change is called an *intermodal transfer*. The following experiential process illustrates two transfers: the first, from visual images to language, and the second from language to movement and/or sound.

♦ The therapist displays craypas, paint, brushes & paper among a therapy group. Each group member is asked to choose two colors and to paint, playing with elements like dots, lines and broad strokes.

♦ The members display their paintings and drawings. Small writing pads are handed out; members walk around, looking at the art pieces, and write responses that emerge in dialogue with each piece, leaving the writing with the piece.

♦ When finished, each member returns to her drawing and the gifts of words she has received. In a quiet space, she arranges the words, adding and discarding what she wishes, until she arrives at a poetic structure she likes.

♦ Sharing of paintings and poems in small groups, following this individual work, functions as a preparation for a presentation in which movement and sounds are added to enhance the imagery.

♦ Finally the therapist facilitates presentation and feedback in the larger group.

Note in the above example that verbal feedback was withheld until the end of the process, and that each experience was carried along with the products to the next phase. The expression flowed continuously, within the same mood, without interruption. Instructions were minimal. In many cases, art expressions may themselves be effectively employed as alternatives to verbal instruction. For example, a dance structure may be redirected and influenced by the introduction of music; or, a group of children may initiate or respond to a movement or sound that signals a change in structure.

A number of considerations will determine the suitability of an intermodal transfer:

♦ What needs emphasis in a session: individuation, socialization, or both in a dynamic, moving process?

♦ Is the expression intensifying, or is there a need for concentration on one level in order to facilitate integration?

♦ Is the goal to enrich, deepen or extend an expression by exploring the same material with a different modality?

♦ Does the person need to move to a more comfortable, less threatening modality?

♦ Is one goal to address a speech impediment, so that a transfer from a painting to a sound improvisation may be of benefit?[6]

An intermodal transfer can also be useful in helping to transform a perceived "weakness" into a strength. For example, a person's pattern of repeatedly being present and withdrawing in cycles while making music may be viewed as a weakness. When this cycling of withdrawal is expressed in a movement improvisation, however, it can transform into an expressive dance that reveals more aspects of the dynamic. Such a dance can be facilitated with the use of strong, huge rubber bands stretched between dancers; the bands will assist in the disclosure of subtle movements of closeness and separation. With a child, a game of "Hide-and-Seek" in a theater structure could similarly enable an intermodal transfer for the cycling withdrawal.

There are many situations in which one might consider an intermodal transfer. On the other hand, certain circumstances may reveal a need to focus on a single modality for an extended period of time. There is no simple recipe for making intermodal transfers, but there is value in becoming sensitive to the possibilities of particular modalities. The sensitivity allows for a fuller repertoire of tools and responses in any given therapeutic situation. By the same token, it is not the intermodal transfer alone that does the therapy. It is the facilitating interaction between people working with each other that allows for deeper connection and expression of feeling. An intermodal transfer can intensify an experience and bring a person more closely in touch with feelings, to reach a fuller catharsis, to expand the meaning, or to enable a more effective group involvement.

Low Skill-High Sensitivity

The reader might note in the above example of an intermodal transfer that the therapist remained at the same level of manual skill, utilizing *simple* materials and their

qualities—from simple colors and shapes to single words or short phrases to non-specific, simple movements, gestures or sounds. This illustrates the principal of a *low skill-high sensitivity* approach, common in intermodal expressive therapy, which facilitates an accessibility to art by anyone, regardless of art experience or training. The approach deserves further comment.

Many of us have been taught that the quality of art lies in the perfection of manual skills that enable us to expertly mold, modulate, change, build and handle art materials. As we investigate the arts of various cultures, however, we find that often what touches us most in art is not virtuosity, but rather something that we might call *competency of expression*. This is not to imply, of course, that virtuosity cannot be beautiful. Nor do we mean to imply that we must imitate the art of other cultures in order to attain competency of expression. However, we can certainly learn from other cultures' sensitivity to material.

For example, arranging flowers or stones and sand in a Japanese fashion can result in an intense expression which builds upon a sensitivity to materials and their meaning in relation to each other. Similarly, the music of the Japanese Noh Theater uses simple bursts of noises, tones and mixed sounds in a mosaic radiating a virtuosity of sensitivity that requires far less manual skill than would the delivery of a virtuoso violin concerto. Contemporary art in Western culture has learned from such disciplines, as might be demonstrated with "minimal music" and "installation art". Patched collages can evoke intense responses sometimes comparable to the photographic realism achieved in a master painting which calls for tremendous manual skill. The art of children often carries more competency in expression than the art of highly studied and technically skilled artists.

Many clients will become motivated to upgrade their skills in mastering certain artistic techniques. This drive to mastery, we feel, is fed by the need to arrive at an expression that is optimally clear and understandable.

Intermodal Superimposition

The following example illustrates three intermodal superimpositions, beginning with visual imagery and *adding* sound, action, body, dance, and finally a theatrical structure, for the purpose of finding a gestalt.

◆ Silvio, 14 years old, painted red and black scribbles, dots and bars in an impulsive manner. Instead of moving directly into an analytical interpretation ("You must be angry!") or a feedback ("I feel afraid when I look at your painting; how do you feel?") or reflecting talk ("What do you see in your painting?"), an intermodal superimposition is introduced to *amplify the imagination.*

◆ Silvio is asked to "play" his painting on a large timpani drum. He had previously explored the percussive instruments, but today had a hard time loosening his arms enough to get the drum's membrane ringing. However, he enjoyed exploring until he entered into an angry pounding. The music was taped.

◆ While replaying the tape, Silvio joined the therapist in a "tribal dance" to his music, adding vocal sounds as he was comfortable.

◆ Now more connected with his feelings that turned towards anger, he initiated a transfer, to act out a theatrical structure that described a hatred for his sister. This formed a transition to the final feedback.[7]

When Silvio danced, he was asked to add sounds with his voice. This technique, intermodal superimposition, in which modalities are added, or layered, rather than moved between, is an alternative to intermodal transfer which can also help to connect to the depth of feelings.

In a musical improvisation, one might add words. Or one might improvise a dance to an original poem, while reciting it. In connection with language, movement, sound and action generally lend themselves best to deepening an experience. Sometimes, however, it might be a word or image that brings a connection to feelings or a more precise understanding of meaning.

Certain factors can work to distract or interrupt a process of intermodal transferring and superimposition, as follows:

♦ Rushing through a session just to fulfill a number of planned transfers or superimpositions defeats the purpose of allowing a person to become comfortable with becoming connected to his feelings. **A too-rapid pace can interfere with the therapeutic process** and may result from the misguided idea that making transfers is more important than the person involved.

♦ **A threatening modality may inhibit the expressing person**, a notion first introduced in the discussion on intrapersonal considerations in intermodal theory, above. To cite an example, a client may describe an incident in which someone moved towards him like a raging tiger, leading the therapist perhaps to enter into a tiger dance. If the individual emerges from a religious background that views dancing as a sin, then the modality might only create discomfort and unnecessary feelings of conflict or guilt. In this case, offering an opportunity to paint the tiger, for example, might be more appropriate.

♦ Sometimes the modality or structure chosen fails to allow for the continuation of the experience, or the product may be lost through a transfer, leading to a failure to recognize the earlier expression. **Every expressing person has a right to feedback!**

Once again, it is a sensitivity to modalities and to people, along with a committed *presence* within a therapy session, that will help minimize the interruption of people's therapeutic processes.

Notes on Part Four

[1]We will address "the phenomenon of the third" in greater detail below, when we discuss the mediated, unmediated and transmediated realms. For now, suffice it to say that the phenomenon of the third refers to a third presence—something apart from the therapist and client—which exists within every therapeutic encounter. We view the imaginal realm as this thing apart from therapist and client, which nevertheless engages both.

[2]In ancient magical consciousness, presence or awareness was in one's center, and the encountered was conjured through an attempt to be one with it. In mythic consciousness, it was directed up toward a *god*, and people found comfort in the ritual of worship. Gebser (1986) suggests that the contemporary "aperspective" world view needs a new consciousness that unites the encountered and its origins in a time-free continuum leading to a holistic completion.

[3]The term "flash" was introduced by Balint (1980) for all the surprising and nonreproducable effects of a relationship that are healing.

[4]The "uncertainty relation" is a phenomenon of quantum physics. It refers to the fact that the simultaneous measuring of the exact location and velocity of a nuclear particle is impossible.

[5]Eddington's theory states that events are not causal. "The events do not just arrive; they are already present, and we meet them on our path."

[6]Incidentally, intermodal transfers lend themselves extremely well to the treatment of learning disabilities, since language itself is an intermodal link. The written word is a visual symbol which needs to be associated with a sound.

[7]Often, a client will instinctively initiate movement into a transfer or feel an impulse to do so.

PART FIVE

Some Thoughts on Research

RE-SEARCH
begins
and
ends
with
the conception
of the
mysterious
UN-KNOWN:
what was in the beginning
and
what will be in the end:
laboring
the
IN-BETWEEN.

We acknowledge the dearth of research in the field of expressive therapy and have reserved this chapter to help promote an increased interest in further study by offering some guidelines, thoughts and above all encouragement to those who dare to address this growing

need. We value the role research can play in helping us to better understand and document our work, in improving the service we offer clients, and in increasing expressive therapy's professional credibility among allied fields. What we hope most to encourage is an approach to research that serves the arts most adequately. This means moving beyond classical research methods designed to explore therapeutic work in schools with vastly different approaches. Writing a case study in the language of a Freudian analyst, for example, is fine for psychoanalytic work; but even if the researcher/practitioner has utilized the arts in the treatment provided, the work remains psychoanalytic and not expressive therapy, for it is grounded in a psychoanalytic paradigm rather than in the tradition of the arts. We have our own language to nurture without borrowing from disciplines inherently foreign to our own. This is our great challenge—and our responsibility if we are to truly carve a place for our profession in the greater community of professional practitioners.

Object Formation

A basic rule of scientific research concerns *object formation*. The *object formation* rule prohibits giving one determination of an object more weight or value than another. Water, for example, is no more determined as a chemical ("H_2O") than as a "fluid substance" in physics or, from a philosophical standpoint, as a "symbol of life." All characterizations of water are true within their respective paradigms.

The *object formation* rule demands that a research method be adequate to the object researched in all aspects of the research process, including planning, set-up, data collection, strategy, evaluation and data processing.

Obviously, one would apply different methods when researching the movement of arctic ice than in the movement of sand dunes in the Sahara. However, it becomes much more difficult to respect the rule when comparing methods applied to human subjects—even more so when the artistic process is involved.

Consider, for example, problems in reversibility and reproduce-ability. Not only is it a formidable task to reproduce the integrity of an individual's experience; but it is also problematic when we consider that the artistic process and its results (paintings, dances and improvisations) can differ from moment to moment even for the same person in a comparable situation. On the other hand, we would be contradicting an essential aspect of art were we to deny that artistic works "grow" out of preceding processes. We cannot alter a sequence of art works without changing the context of the whole (Tüpker, 1990).

If we consider the rule of object formation in research into the therapeutic relationship in expressive therapy, we observe the domains of the mediated, unmediated and transmediated realms as different determinations of the same. A method that may be effective in the mediated realm—for example, a test of a medication's effectiveness—would be inadequate for researching the effectiveness of a human encounter in therapy. The same principle applies to methods that attempt to grasp only the unmediated or transmediated.

Finally, if we wish to find an adequate method of research, we must remember that any model we use will always be only an image of reality and not literal reality itself. In other words, each model belongs in the realm of imagination or imaginal reality, not in the realm of literal reality. The images influence our effective reality and therefore influence our observations, cognitions and acts. Moreover, as images, those models result from creative acts.

The philosopher of science Beveridge (1950) muses that artists and scientists are united in their attempts to find images. The mathematician Müller (1985) offers examples that show how the process of research and especially the discovery of solutions often occur in a spontaneous manner, much like mystical experiences, and how the discoveries possess the character of arriving images. Science connects with imagination in the same way that art does. Müller himself went so far as to say, "Scientists are artists who spend their artistry in hiding their art" (1985, p. 117).

The researching mind constantly creates models and images which contradict or replace former ones. And even though it differs from literal reality, the never-ending creative process within science and philosophy helps humanity to stay in a discourse about truth. This continuous effort resembles the work of poets, storytellers and writers. Levi-Strauss says that writers and contemporary scientists pursue truth with the same logical stringency; they merely use different strategies (1966, p. 15).

Without a doubt, art, philosophy and science all connect through the creative act and imagination. The function of the creative act, however, may take several forms:

> In the arts, it is a ritual of re-creating truth.
> In philosophy, it is the vision of a sense of truth.
> In science, it is a sketch of an order and law of truth.

If the creative act and imagination get lost, the boundaries between these different schools of thought solidify. Consequently, one may claim to be the "only" guardian of truth, and we confront the danger of fundamentalism and literalism. A physics professor once said when commenting on Cartesian research, which takes only meas-

urable quantities and independent cause/effects into account, "If Einstein would have done his research without imagination, exclusively using Newton's and Maxwell's laws without questioning them, he would probably have only confirmed them and would never have created a theory of relativity." This example serves as a metaphor for those applying theories to expressive therapy research which are not indigenous to the arts. On the same theme, Portmann (1973) suggests that every research method must create its possibilities from its own object formation and should not restrict imagination by limits that come from other realms (p. 137).

The correlation between the artistic process, the creative act, the artistic attitude and the transmediate third are clear to expressive therapists; however, they also seem to apply to scientists, who Müller viewed as hidden artists. Einstein himself seemed to be referring to the transmediate when he said, "The knowledge about the real existence of the inexplicable, that reveals itself as the greatest truth in gleaming beauty and from which we have only a faint presumption—this knowledge and this notion are the core of all genuine religiosity" (Behnken, 1985, p. 8). In this connection to the creative act, imagination and the transmediate lies the difficulty and the opportunity of scientific research in expressive therapy. Through this link we enter a meta-scientific realm, into a heuristic research of the very phenomenon of discovery which is the essence of creative therapy and science. It presents the same difficulties we face in all the research and theories about imagination, creativity and spontaneity.

The neurologist Oliver Sacks (1987) finds the difficulty of this connection even more deeply rooted. He views the very act of thinking as art and sees in this the great challenge of scientific research in psychology. "No scientific psychology," he states, "can begin to call itself com-

plete until it can begin to account for music in particular and art in general." He continues:

We are beginning to understand the mechanical computational abilities of the nervous system quite well; but over and above these possibilities, also primordial, and beneath these I think we need a different way of thinking entirely to understand how art works. And I think that life and the mind in anyone and at all times is essentially a matter of art. I think thinking itself is an art and not a mechanical sequence.

The artistic attitude does not advocate eliminating difficulties, limits and disturbances; rather, it approaches them as challenges that may lead to the emergence of images. In this spirit, we might approach our difficulty in finding adequate research methods for expressive therapy in a manner that takes into account the mediated, unmediated and transmediated realms.

In his research about the education of expressive therapists, Shaun McNiff (1985) postulates the importance of research and building theory indigenous to the arts. With the word indigenous, he appeals to the same criteria we are promoting here. In what follows, we wish to present some of the phenomenological research methods that we have found to be in congruence with these requirements.

Research Methods

Hermeneutic Research

With the assumption that descriptions of therapeutic relationships in practice themselves possess an art-indigenous character, they become part of the arts. Documentation of these relationships then become literature and,

as such, sources of hermeneutic inquiry—as long as they are not written in a reductionist, medical or psychological jargon that draws conclusions by generalizing instead of reaching to greater depth by drawing attention to the particular, as happens in poetic language. Published case studies by Oliver Sacks exemplify a non-reductionist approach to documentation. Yvonne Escher (1988) also presents an excellent example of intermodal documentation of research in her film, *"Bild der Seele"* (Image of the Soul).

Hermeneutic research may take the form of an interpretation in the tradition of literary criticism or phenomenology. The essence distilled through such interpretations can be ordered and compared through the application of a qualitative research methodology.

Art Indigenous Analysis

Art indigenous analysis, which approaches the study of the therapeutic process *artistically*, or as an artist would, can find theoretical grounding in crystallization theory and intermodal theory.

In this category we find the "morphology of music therapy" as one of the more advanced methods. Musicological considerations build the basis of observation. The relationship, for instance, is present in the polyphony of an improvisation between therapist and client. The language of music need not be translated into a jargon foreign to music, and yet it still reflects psychological depth. We attend, for example, to the way a theme is changed, supported, picked up later on, opposed in a supportive way, or confronted with a musical "attacca" (Weymann, 1986).

We find similar principles in dance movement analyses by Laban (1947), which were developed further by dance therapists and introduced as the "effort and shape"

method (Dell, 1980). Here we find a language indigenous to movement and dance that is applied to observation. In an extended understanding of the method, we could also consider Moreno's theater analogy to the therapeutic process (1973).

Dialogue Transcripts of the Archetypal Tradition

Dialogue transcripts have been well presented by McNiff (1988, 1992 & 1993) and introduced in the thesis research seminars at Lesley College Graduate School's program in Expressive Therapies. This method can be extended to all the art disciplines.

The essence of this method is that the emergent art is respected as the arriving third that is beyond our control. Therefore, the research focuses on the aesthetic response uttered in a dialogue with the image. If the dialogue is guided in the strict discipline of archetypal phenomenology, as taught originally by Hillman (1977), the transcripts of such dialogues will reveal Psyche "uninterpreted," so that images may speak for themselves, enabling the building of rich data for subsequent research in methodology and the effectiveness of therapy and therapist.

Aesthetic Methods

Here we focus attention on the phenomenon of the artistic process with respect to the arts' material, structure, form and content. The method resembles the art-indigenous analysis, but it extends the structural and formal body of knowledge in the arts (as, for example, musicology) to historic and aesthetic concepts. A client's work of art, then, is viewed in the context of the tradition of art history and aesthetics.

As an example, Erisman (1988) presents client portraits in an art historic and aesthetic context and develops a theory that he calls "dynamic aesthetics," helping to un-

derstand the psychodynamics of the client without resorting to psychological models foreign to the arts and their interpretations. A theory that also belongs in this category is polyaesthetics.

Metaphorical Methods

The therapeutic relationship can be considered metaphorically in images that can be viewed as pieces of art. Examples include a "landscape of soul," a travel story or a movie—where mediated, unmediated and transmediated beings live, grow, dwell, work, are in conflict and find peace.

An interesting example comes from Lebhard (1988). He looked at painted landscapes of his sessions, then applied principles of classical geography and meteorology to research them towards an understanding of changing moods in his work with a patient. Weather and climate thus served as metaphors for feelings and moods.

The images of inner and outer worlds could be brought into further resonance and research with theories from the fields of physics or biology. Take, for instance, the morphological field theory of Sheldrake (1981), who approaches form and behavior governed by an image beyond the individual. "The approach I am putting forward is very similar to Jung's idea of the collective unconscious," he explains. "The main difference is that Jung's idea was applied primarily to human experience and collective memory. What I am suggesting is that a very similar principle operates throughout the entire universe" (Sheldrake, 1981, pp. 11-25).

Qualitative versus Quantitative Research

This discussion would be misunderstood if it promoted only the possibility of *qualitative* research methods.

Research questions remain which are very well-suited for quantitative research. These questions are restricted to mediated and unmediated fields, of course, but are nonetheless very relevant to our work as expressive therapists. Some questions from the mediated realm concern the potential hazards of particular art materials, the suitability of various musical instruments, and the optimal firing qualities of clay, as well as questions about scheduling, space requirements and the mechanics of conducting therapy. Studies that address these questions might do well to use traditional approaches to data collection, measurement and statistical analyses.

Other questions might relate to demographics of particular populations, trends in employment and in financial support for expressive therapy in institutions, and the effects of personality versus schooling upon therapist competence; these touch on the unmediated realm. Within the unmediated realm, classical research methods of the qualitative type may be most adequate. These would include methods like action research, participative observation and phenomenological inquiry (Giorgi, 1985), and heuristic research methods. Moustakas (1990) even proposes a method that encourages the artistic expression of the researcher as a source of information on his or her bias, a method that could also be applied to a study of subjects.

When it comes to exploring the transmediated realm, the only responsible approach available to us is an evocative, exploratory, poetic one, one which utilizes art to study art. Here we might find material presented in the form of films, exhibitions, creative writing, even novels. Though this type of study cannot always enable us to make generalizations or draw conclusions, it can enrich and deepen our understanding of transmediated events and processes, which remain among the most provocative material we encounter as therapists.

Closing Remarks

We hope that we have helped to define Intermodal Expressive Therapy as a specialized and focused psychotherapeutic discipline grounded in the imaginative tradition which all the arts have in common. We have found it to be a formidable task, and when strict allegorical definitions have inevitably eluded us, we have relied upon imaginative dialogue—a basic tool of expressive therapy—to explore and enrich our understanding of the principles conveyed. Consequently, the work has been less concrete than it has been evocative. We are sensitive to the compelling human drive towards the concrete, especially in contemporary society; however, we know of no other way to effectively explore material which deals so intimately with the arts and Psyche. Moreover, our practicing in the field has revealed time and time again a healing power in the arts that can only survive in a nonlimiting, imaginative realm.

We hope further that this marks a mere beginning in the exploration of intermodal expressive therapy, which to date has not been fully explored in the literature, nor fully "explained" to the public, who stand to gain the most from the fruits of this profession.

We applaud the outstanding work of the students and expressive therapists we have known who have informed our own study of the field and urge them ever forward in finding space and support to practice their very important work and contributions to our world.

In closing, and staying true to the spirit of our work, we wish to end with a heretofore unpublished poem by Truman Nelson, a prolific writer and author of such well-known works as *Sin of the Prophet* (Boston: Little, Brown, 1952) and *The Right of Revolution* (Boston: Beacon Press, 1968). Nelson crafted the poem with the express purpose of honoring the field of expressive therapy:

Most people I know are frozen.
But not to death.
Only their emotional life is frozen to death.
Not that they don't have emotion from time to time:
But it only flickers up, palely blue
Through a crack in the ice.
When the waters of their tears...
Their self pity, quenches it.

Without the self pity
They can burn a hole in the ice
Or make a great, thunderous crack
Which shivers people to life all around them.
And then the people scurry fearfully to mend the crack
Throwing thick blankets of therapy, treatment
Pills, dope, humoring and adjustments
Over the crack to smother the flames below.

Let them burn. Let them burn.
Feed the flames, melt the ice.
Because therein the ice is trapped
All the dead world's beauty and advance,
Waiting to be liquified; rich and fragrant
Nourishing as a stew...gold flecks
To put the patina of the eternal sun upon the world,
A splendor for life...forever.

—Truman Nelson, November 15, 1978

About the Authors

The three individuals who collaborated in this effort are Paolo Knill, Helen Barba and Margo Fuchs.

Paolo J. Knill, Ph.D., Dr. h.c., is Provost at the European Graduate School, Switzerland, and Professor Emeritus, Lesley University, USA. He initiated the International Network of Expressive Arts Therapy Training Centers and founded the ISIS European training institutes. As a teacher and performing artist, he has traveled internationally and published extensively, including the book, *Ausdruckstherapie* (Expressive Therapy).

Margo N. Fuchs, Ph.D., is Dean of the Masters Program in Expressive Arts Therapy at the European Graduate School, Switzerland, and a former Assistant Professor at Lesley University, USA. She is a registered therapist and play therapy supervisor, a certified expressive therapist and a licensed mental health counselor. Margo Fuchs works in private practice and teaches at training institutes in Europe and the USA. She is a poet and the author of *Season-ing Life*.

Helen Barba, M.A., A.T.R., CCMHC is a musician, expressive therapist and teacher with broad clinical experience in private practice, community mental health and correctional settings. She is currently completing her doctoral dissertation in songwriting and human shadow studies and lives with her four children in Northfield, Minnesota, USA.

REFERENCES

Agell, G. "The Place of Art in Art Therapy: Art Therapy or Arts Therapy," in *American Journal of Art Therapy*, Vol. 21, July 1982.

Alesch, C. "The Unity of the Senses," in *Polyaisthesis*, C. Alesch & P. Krakauer (Eds). Wien, Austria: Verb. Wissensch. Gesellschaften, 1991.

_____, & P. Krakauer (Eds). *Polyaisthesis.* Wien, Austria: Verb. Wissensch. Gesellschaften, 1991.

Anderson, W. *Ethos and Education in Greek Music.* Cambridge: Harvard University Press, 1966.

Armstrong, A. H. "The Divine Enhancement of Earthly Beauties," in *Eranos Lectures.* Dallas: Spring Publications, 1987.

Arnheim, R. Guest Lecture, Lesley College Graduate School, Cambridge, Massachusetts, February 1987.

Bachmann, M. *Dalcroze Today: An Education through and into Music.* Oxford, England: Clarindon Oxford University Press, 1991.

Balint, M. *Der Arzt, sein Patient und die Krankheit.* Stuttgart: Klott-Cotta, 1980.

Barba, H. *An Overview of Áñïïõéá in Hellenic Times* or *It's All Greek to Me.* St. Olaf College, 1981 (unpublished).

_____. *A Psychology of Recurring Imagery* (Master's Thesis). Cambridge: Lesley College, 1988.

Behnken, H. & M. Steignitz. *Vorwort*, in *Erkenntnisgrenze-Grenzerfahrung.* Locumer Protokolle 18: Rehburg-Lokum, Akademie-Lokum, 1985.

Berlin, R., et. al. "Metaphor and Psychotherapy," in *American Journal of Psychotherapy*, XLV(3), July 1991.

Beveridge, W. *The Art of Scientific Investigation.* New York: Norton, 1950.

Bolles, E. *Remembering and Forgetting: Inquiries into the Nature of Memory*. New York: Walker & Company, 1988.

Boss, M. *Psychoanalysis and Daseinsanalysis*. New York: Basic Books, Da Capo Press, 1982.

Buber, M. *Ich und Du*. Heidelberg: Lambert Schneider, 1983.

Copei, F. *Der fruchtbare Moment im Bildungsprozess*. Stuttgart: Kröner, 1970.

Cytowic, R. *The Man Who Tasted Shapes*. New York: Putnam Sons, 1993.

Dabrowsky, K. *Mental Growth through Positive Disintegration*. London: Gryf Publications Limited, 1972.

Dalcroze, E. *Rhythm, Music and Education*. New York: I. P. Putman, 1921.

Decker-Voigt, H. *Musik als Lebenshilfe*. Lilienthal, Germany: ERES, 1975.

_____. *Spiel und Aktion*. Düsseldorf: Schwann, 1980.

Dell, C. *Primer for Movement Description Using Effort-Shape & Supplemental Concepts*. New York: Dance Notion Bureau, 1970.

Eddington, A. *Space, Time & Gravitation: An Outline of General Relativity*. Cambridge: University Press, 1935.

Escher, Y. *Bild der Seele*. Steckborn, Switzerland: Bodenseefilm, 1988.

Erismann, M. *"Die Dynamische Aesthetik für eine Pädagogik der Gestaltenden Therapie."* IACCT Conference, Basel, 1988.

Flores, F. & Winnograd, T. *Understanding Computers & Cognition*. New York: Addison-Wesley Publishing Company, 1987.

Frohne, I. *"Multimediales Vorgehen in der Musiktherapie,"* in *Handbuch der Musiktherapie*. Lilienthal, Germany: ERES, 1983.

_____. (Ed). *Musik & Gestalt*. Paderborn: Junfermann Verlag, 1990.

Fuchs, M. *"Ganzheitliche Aspekte zur Kunst des Heilens* (Aspects of integration in the arts therapies)," in *Hamburger Jahrbuch,* Decker-Voigt (Ed). Lilienthal: ERES, 1986.

_____. *"Poesis, die psychotherapeutische Ordungskraft des geschrieben und gesprochenen Wortes,"* in *Musik-, Tanz-und Kunstberapie.* Münster, West Germany: Hettgen Verlag, 1989.

Gadamer, H. *Truth and Method: The Principle of Effective History.* New York: The Seabury Press, 1975.

Gebser, J. *The Ever-Present Origin.* Stuttgart: Ursprung & Gegenwart, 1986.

Gendlin, E. *Focusing.* New York: Bantam Books, 1981.

Giorgi, A., Ed. *Phenomenology and Psychological Research.* Pittsburg: Duquesne University Press, 1985.

Grant, M. & Hazel, J., *Lexicon der antiken Mythen & Gestalten.* Munich: DTV, 1987.

Grob, P. *Beziehungseffekte in der Medizin,* Manuscript available Brambergstr. 18, Luzern Switzerland, 1989.

Grotowski, J. *Towards a Poor Theater.* NY: Simon & Schuster, 1970.

Hanh, T. *The Moon Bamboo.* Berkeley, CA: Parallax Press, 1989.

Heidegger, M. *Basic Writings.* D. Krell (Ed). San Francisco: Harper, 1977.

Heisenberg, W. *Wandlung in der Grundlage der Naturwissenschaft,* Zuerich: Hirzel, 1949.

Hillman, J. *A Desperate Need for Beauty.* Titus Workshop, Lesley College Graduate School, May 13, 1994.

_____. *Loose Ends: Primary Papers in Archetypal Psychology.* Dallas: Spring Publications, 1975.

_____. *Re-Visioning Psychology.* New York: Harper Colophon Books, 1977.

Hjerter, K. *Doubly Gifted: The Author as Visual Artist*. New York: Harry N. Abrams, 1986.

Kluge, F. *Etymologisches Wörterbuch*. Berlin: Gruyter, 1975.

Knill, P. *"Auf dem Weg zu einer Theorie musikorientierter Psychotherapie,"* in *Musiktherapeutische Umschau*, Bd. 8, Heft 1, Stuttgart/Frankfurt: Fischer/Bochinsky, Feb 1987.

_____. *Ausdruckstherapie*. Lilienthal, Germany: ERES, 1979.

_____. *"Das Kristallisationsprinzip in einer Musik-orientierten psychotherapie,"* in *Musik und Gestalt*, I. Frohne, Ed. Paderborn: Junferman Verlag, 1990.

_____. "Eros on the Cruise with Rhino: The role of imagination in the creative arts therapies," in *Create: Journal of the Creative & Expressive Arts Therapies Exchange*, 2, 1992.

_____. "The phenomenon of Change in the Arts and Treatment of Substance-use Disorder," in *Japanese Bulletin of Arts Therapy*, Vol. 22, No. 1, 1991.

_____. "Researching Imagination or the Art of Learning," in *Create: Journal of the Creative and Expressive Arts Therapies Exchange*. Vol. 1, 1991, pp. 5-12.

_____. "Theory Indigenous to Art: Phenomenology of the arts process as a theoretical base for art therapy," in *Journal of the International Association for Art, Creativity & Therapy* (IAACT), Vol. 3, Heidelberg, June 1986.

Laban, R. *The Mastery of Movement*. London: McDonald & Evans, 1947.

Labhardt, F. *Die Landschaft als Ausdruck der Stimmung*. IACCT Conference, Basel, 1988.

Landreth, G. *Play Therapy: The Art of the Relationship*. Muncie, Indiana: Accelerated Development, Inc., 1991.

LeBoef, M. *Creative Craft: Imagination & Inspiration*. Landsberg, Germany: Am Lech Verlag, 1988.

Levine, S. *"Die Idee der Integration in den Kunsttherapien,"* in *Mitteilungsblatt der IAACT,* Heidelberg, April 1990.

Levine, S. *Poiesis: The Language of Psychology and the Speech of the Soul.* Toronto: Palmerston Press, 1992.

Levi-Strauss, C. *The Savage Mind.* Chicago: University of Chicago Press, 1966.

Liao, L. *"Polyästhetik und Eigengesetzlichkeit der Künste,"* in *Polyaesthesis Journal,* 4 (2), Salzburg, Mozarteum, 1989.

Lorenz, K. (Ed). *Meyers kleines Lexikon der Philosophie.* Mannheim: Bibliographisches Institut, 1987.

Ludwig, A. *Principles of Clinical Psychiatry.* New York: The Free Press, MacMillan Publishing Company, 1980.

Marks, L. *The Unity of the Senses: Interrelations among the Modalities.* New York: Academic Press, 1978.

Mastnak, W. Popper, *Gebser und die Musikpädagogik.* München-Salzburg: Musikverlag Emil Katzbichler, 1990.

Maturana, H. and F. Varela. *The Tree of Knowledge.* Boston: Shambala, New Science Library, 1987.

McKim, E. *Boat of the Dream.* Roxbury, MA: Troubadour Press, 1988.

McNiff, S. *Art As Medicine.* Boston: Shambala, 1992.

_____. *The Arts and Psychotherapy.* Springfield, IL: Charles C. Thomas, 1981.

_____. *Educating the Creative Arts Therapist: A Profile of the Profession.* Springfield, IL: Charles C. Thomas, 1985.

_____. *Fundamentals of Art Therapy.* Springfield, IL: Charles C. Thomas, 1988.

_____. "The Man Who Talks to Paintings. An interview with Coot/Napear," in *New Age Journal,* 1993, pp. 66-69.

_____. "Pantheon of Creative Arts Therapies: An Integrative Perspective." in *Journal of Integrative and Eclectic Psychotherapy*, 6(3), Fall 1987.

Meier, G. *Im Anfang war das Wort*. Bern: Haupt, 1988.

Molitor, G. Untitled seminar paper, Lesley College Graduate School, Cambridge, Massachusetts, 1993.

Moreno, J. & Z. *Psychodrama*, Vol. II. NY: Beacon House, 1959.

_____. *The Theater of Spontaneity*. NY: Beacon House, 1973.

Moore, T. *Care of the Soul*. New York: HarperCollins, 1992.

Moustakas, C. *Heuristic Research Design, Methodology & Applications*. Newbury Park, CA: Sage Publications, Inc., 1990.

Müller, K. *"Naturwissenschaft und Mystische Erfahrung,"* in *Erkenntnisgrenze-Grenzerfahrung*. Locumer Protokolle 18: Rehburg-Locum, Akademie-Lokum, 1985.

Palmer, Richard E. *Hermeneutics*. Evanston: Northwestern University Press, 1979.

Petersen, P. *Der Therapeut als Künstler*. Paderborn: Junfermann Verlag, 1985.

Portmann, A. *Biologie und Geist*. Frankfurt: Suhrkamp Taschenbuch, 1973.

Pulasky, M. A. *Understanding Piaget: Introduction to Children's Cognitive Development*. New York: Harper & Row, 1971.

Rogers, N. *The Creative Connection: Expressive Arts as Healing*. Palo Alto, California: Science & Behavior Books, Inc. 1993.

Roscher, W. (Ed). *Polyästhetische Erziehung*. Köln: Dumont, 1976.

_____. *"Polyaisthesis-Polyästhetik-Polyästhetische Erziehung,"* in *Polyästhetische Erziehung*. Köln: Dumont, 1976.

Rouche, J. "The Camera and Man," in *Principles of Visual Anthropology*. Den Haag: Paul NockingsMouton, 1975.

Sacks, O. *Weekend Edition*, an interview on National Public Radio, April 4, 1987.

Salber, W. *"Konstruktion psychologischer Behandlung,"* Bonn, cited by E. Weymann, *"Über die Beweggründe des musik-therapeutischen Handelns,"* in *Materialien zur Morphologie der Musiktherapie* (Hardwaldklinik: Institut für Musik-therapie und Morphologie, Heft 1, 1986), 1980, p. 28.

Schröder, M. M., Schröder, M. S., *Spiegel der Seele*. Stuttgart: Klett-Cotta, 1992.

Spitzer, R. (Ed). *Diagnostic and Statistical Manual of Mental Disorders* (DSM-III-R), 3rd Edition, Revised. Washington, D.C.: American Psychiatric Association, 1987.

Stanislavski, K. *Creating a Role*. NY: Theater Arts Books, 1961.

Stein, B. & M. Meredith. *The Merging of the Senses*. Cambridge: M.I.T. Press, 1993.

Szeemann, H. *Der Hang zum Gesamtkunstwerk*. Aarau: Sauerländer Verlag, 1983.

Tüpker, R. *"Wissenschaftlichkeit in Kunstherapeutischer Forschung,"* in *Musiktherapeutischer Umschau*, Vol. 11, Heft 1, 1990.

Walk, R. and H. Pick. *Intersensory Perception and Sensory Integration*. New York: Plenum Press, 1981.

Waser, G. *"Auf dem Wege zu einer gestaltenden Psychologie und Psychotherapie,"* in *Musik-, Tanz- und Kunsttherapie, Zeitschrift für künstlerische Therapien*. Vol. 3, September 1990. Stuttgart/New York: Theime, 1990.

_____. "The Role of the Communicative Unconscious in Creative Therapy, with Particular Reference to Transitional Relationships," in *CREATE: Journal of the Creative & Expressive Arts Therapies Exchange*, Vol. 1. Toronto, 1991.

Webster's New Twentieth Century Dictionary, 2nd Edition, 1983.

Weymann, E. *Materialien zur Morphologie der Musiktherapie*. Zwesten, Germany: Institut für Musiktherapie und Morphologie Hardwaldklinik, 1986.

Zinsli, P. *Der Berner Totentanz des Niklaus Manuel*. Bern: Verlag Paul Haupt, 1979.

Index